IMAGES
of America

ALONG THE
POTOMAC

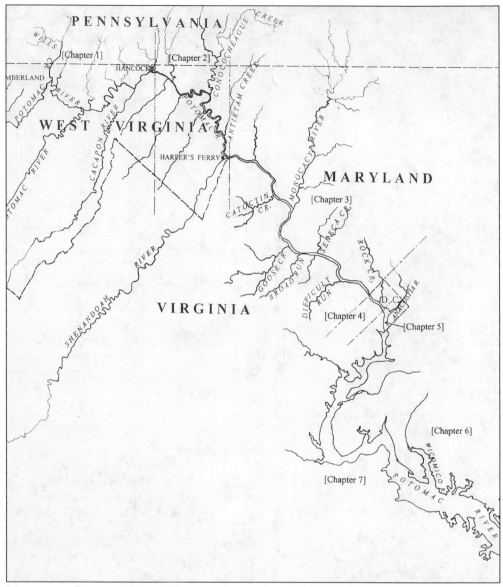

MAP OF THE POTOMAC RIVER. The river that we know today as the Potomac got its start in a process of mountain building we know as the Alleghenian orogeny about 735 million years ago. This resulted from the collision of three land masses, later to be called the continents of North America, South America, and Africa, to form a super continent. This continuing phenomenon and subsequent deposition and erosion account for the northeast/southwest ridges and valleys that determine the shape of this region. About 160 million years ago, the super continent, Gondwanaland, broke apart, starting the Atlantic expansion. This resulted in the water flow on the east coast shifting directions from west to east into the Atlantic Ocean. A huge meteorite crashed into what is today the mouth of the Chesapeake Bay about 35 million years ago, creating a great crater and causing the southward flow of the lower river. As the river wore down, the heights produced by the ongoing mountain building, it produced water and wind gaps. By two million years ago, the river was recognizable as the entity we have named the Potomac. (DH.)

IMAGES
of America

ALONG THE POTOMAC

Philip W. Ogilvie
and Potomac Water Trail Association

ARCADIA
PUBLISHING

Published by Arcadia Publishing
Charleston, South Carolina

Printed in the United States of America

Library of Congress Catalog Card Number: Applied for.

For all general information contact Arcadia Publishing at:
Telephone 843-853-2070
Fax 843-853-0044
E-Mail sales@arcadiapublishing.com
For customer service and orders:
Toll-Free 1-888-313-2665

Visit us on the Internet at www.arcadiapublishing.com

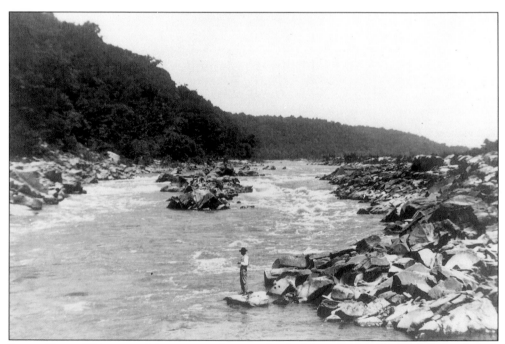

LITTLE FALLS. This turn-of-the-century photograph of a fisherman by F.R. Wheater symbolizes the human-nature-history interaction that is the Potomac River. (MLK – 6012.)

CONTENTS

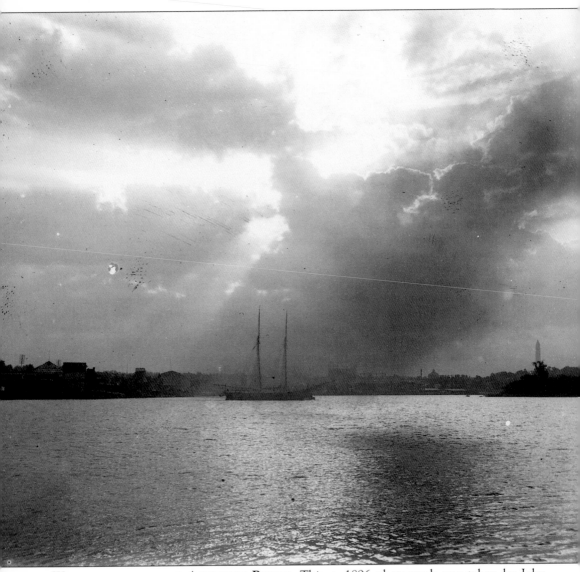

WASHINGTON FROM THE AQUEDUCT BRIDGE. This *c.* 1896 photograph was taken by John Meigs (1875–1944) with a view camera when there were no bridges across the Potomac in the Metropolitan Area between the Aqueduct Bridge at Georgetown and the Long Bridge in Washington. Meigs, later an important civil engineer, was a senior at Columbian College (now George Washington University) when he took this spectacular picture. To the right of this view is Roosevelt Island, behind it—the Washington monument, in the center—the gas light storage tank on the east end of Georgetown waterfront, and finally, the active port of Georgetown. This is the reciprocal view from the painting on page 70. (HSW — M20A.)

INTRODUCTION

Traditionally, the Potomac River Basin is divided into six physiographic provinces: at its origin the **Allegheny Plateau**; next, the wrinkled **Ridges and Valleys**; followed by the **Great Valley**, of the Shenandoah in Virginia and the Cumberland Valley in Maryland and Pennsylvania; bounded by the **Blue Ridge** mountains; the **Piedmont** hills at the foot of the blue ridge; and, below the falls, the **Coastal Plain**. Each of these divisions is reflected in its assemblage of plants, animals, and culture. Over time there have been changes to all three, some caused by climactic shifts, but most through human actions. Some as benign as the introduction of maize (Indian corn) about 1,900 years ago, and some as devastating as the accidental importation of the Chestnut blight in 1904 that wiped out one-fourth of the forest.

The coming of the Europeans to the basin about 400 years ago resulted in a major change in culture, specifically in agricultural methods, manufacturing, and game management, which has also resulted in many changes both intentional and accidental. Industry has left its mark on the Potomac River from seductive waterpower to the intense industrialization made possible by the conversion to steam power. The consequent destruction of the forests and establishment of a coal-mining industry resulted in major ecological change over the next 100-year period. Many of the changes were also effected by the increased density of human population in the basin.

From 1938 to 1945, the political entities that occupy the Potomac Basin (the District of Columbia, Maryland, Pennsylvania, Virginia, and West Virginia) came together to form the Interstate Commission on the Potomac River Basin (ICPRB). In the subsequent 60 years, the river has recovered much of its biological potential as pollution has been reduced and land practices have been improved.

This book is an attempt to reflect these influences visually and to display some of the changes that have resulted. The pictures span the last 200 years and reflect artists in mediums as diverse as pencil and camera. It is not a guide to river access, to hazards, or to the relative difficulty of paddling. Such a guide already exists; it is *Maryland and Delaware Canoe Trails* by Edward Gertler, Seneca Press.

Fifty years ago Frederick Gutheim published *The Potomac* in the *Rivers of America Series*. I had the good fortune of reading *The Potomac* for the first time as an undergraduate. It had a great effect on the rest of my life. Former Congressman Gilbert Gude has written two books, *Where the Potomac Begins: A History of the North Branch Valley* (1984) and *Small Town Destiny: The Story of 5 Small Towns Along the Potomac Valley* (1989). These books are a small reflection of his life work in preserving the river and making it available to the citizens of the basin. This book is dedicated to these two men and their contribution to the river.

—Philip W. Ogilvie

ACKNOWLEDGMENTS

A book such as this would not be possible without the help of numerous people. The capacities of some are obvious, while others have more obscure roles. Thanks to the following: the board of the Potomac Water Trail Association for their cooperation throughout, particularly to Franz Gimmler, Steve Swartz, Judy Lathrop, and Robert Pauline; Don Briggs of the Potomac Valley Field Office of the National Park Service, who had the vision to see that a guide such as this was needed and who generously provided a grant to pay for the use of historical photographs; the Accokeek Foundation and to Helen Nelson for administering that grant; Donald A. Hawkins for drawing the maps that introduce each chapter; each of the repositories or individuals that have supplied photographs, engravings, drawings, or paintings my thanks; Andrei Kushnir, Wanda Paxton, Michael Piecnocinski, Josephine B. Thoms, and Frank Wright, contemporary artists who all gave permission for the use of original art work; Franz Gimmler, Judy Lathrup, Robert W. Pauline, Steve Swartz, and Neal Welch, who all gave permission for the use of contemporary photographs; Mary Ternes of the Washingtoniana Division of the Martin Luther King, Jr. Library, District of Columbia Public Libraries, for her knowledge of and assistance with the wealth of photographic resources of that library; Wanda Dowell, Director of the Fort Ward Museum Library for her assistance in making the resources of her library available; Gail Redmond, Librarian and Archivist of the Historical Society of Washington, D.C. for helping in every way possible to make their collection accessible; Lucinda "Cindy" Janke, curator of the Kiplinger Washington Collection for having the best organized and most easily accessible collection in the region; Ron Schoeberlein, David Prencipe, Ruth Mitchell, and Robert I. Cottom, whose combined efforts were necessary to make the material from the Maryland Historical Society available; R.J. Rockfeller of the Maryland State Archives for making that material available; Donald Schomette for generously sharing material on Mallows Bay; George H. Shoemaker of Westvaco for making a contemporary photograph of their plant at Luke, Maryland, available; the Maryland Department of Natural Resources, National Archives and Records Administration, and the Naval Historical Foundation.

Finally, I would like to thank those whose efforts actually produced the photographic copies, to Pam Minor of Photo Solutions for service above and beyond the call of duty, and to the other laboratories, including Asman, King Visual Technology, Maryland Historical Society Photo Services Department, National Geographic, and the Naval Historical Foundation Photographic Service.

One

THE UPPER POTOMAC
THE FAIRFAX STONE TO HANCOCK

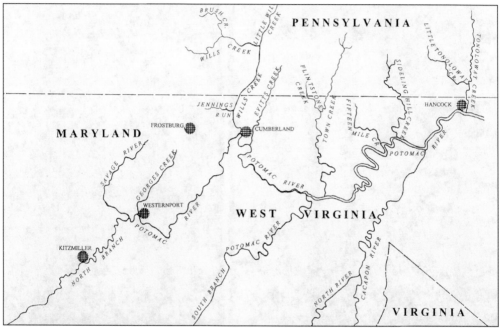

UPPER POTOMAC. The survey of 1736 determined the headwaters of the Potomac River to be the spring at the origin of the North Branch, so, technically, the river is the North Branch until it joins with the South Branch just east of Oldtown (named for an aboriginal settlement occupying the site until displaced by the Europeans). This area west of Hancock brings back the era of exploration, trading, and the Anglo-French War of Empire we know as the French and Indian War. It is the land of names like Charles Polke (the great-granduncle of President James Knox Polk), who established a trading post, at what would become Hancock, in about 1721; Thomas Cresap, who founded Oldtown in 1741; George Washington, who explored and surveyed the region; James Inness, who built Fort Cumberland in 1754; Thomas Stoddert, who built Fort Tonoloway in 1755; and Meshach Browning, a professional hunter who moved from Flintstone to the mountains surrounding the headwaters of the Potomac to follow the disappearing game at the end of the 18th century. It was along this portion of the Potomac that the Conestoga trace supplied the first land route west; it was through this valley that General Edward Braddock led his ill-fated expedition against the French. This is also the land of unbridled exploitations of the area's natural resources. While much of this destruction has been corrected, it is impossible not to be very aware of it south of the impounded Jennings Randolph Lake. (DH.)

EASTERN HEMLOCK. The dominant tree in this area at the time of the 1746 survey was the Eastern Hemlock. Thomas Lewis, one of the surveyors, described the area in his journal, using his own somewhat eccentric spelling, capitalization, and punctuation: "Exceding well timbred with Such as very Large Spruce pines [Hemlock] great multituds of Beach and Shgartrees [Maples] Chery trees the most and finest I ever Saw Some three or four foot Diameter thirty or forty foot without a Branch. Some few oaks Chesnuts and Locusts tho' not maney &c" Today the area immediately around the Fairfax stone is all park-like, with no mature trees. Throughout the area, hemlocks are dying as a result of an Asian aphid, which was accidentally introduced in 1924. (Trees.)

FAIRFAX STONE. In 1649, Charles II of England granted to seven Cavalier gentlemen who had supported his father and, as a result, lost their English estates, all of Virginia between the Rappahannock and the Potomac Rivers (more than 5,000,000 acres). By 1719, Thomas, sixth Lord Fairfax, controlled all of this grant and it became known as the Fairfax tract. It was not until 1745 that the English Privy Council found that the Fairfax lands included all the territory between the Potomac and the Rappahannock Rivers lying east of a straight line from the headwaters of the Potomac, as established by the survey of 1736, to the headwaters of the Rappahannock. A pyramid-shaped stone marked with an Fx and a baron's coronet was placed by surveyors on October 23, 1746, to mark the headwaters of the Potomac River. The stone was destroyed by vandals in the 1880s; it was later replaced on August 12, 1910. In 1957, after several replacement stones, the West Virginia Central and Pittsburgh Railroad gave four acres of land surrounding the Fairfax Stone to the West Virginia State Park System. The state placed a natural boulder over the spring that marks the headwaters of the North Branch of the Potomac River, and on the boulder was placed a bronze tablet. This 1973 photograph shows former Congressman Gilbert Gude (on the right) and his pilot, Harry Lech, drinking a toast to the Potomac. (MLK – 4492.)

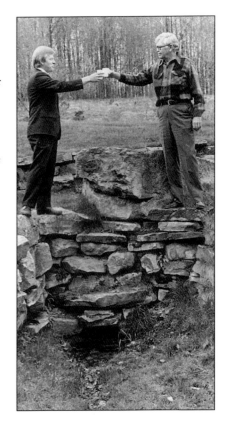

10

LAUREL. The complex of *Rhododendron* and *Kalmia* that we know today as Rhododendron, Azalea, and Mountain Laurel were all lumped together by the early explorers of the upper Potomac as Laurel. While we uniformly praise them for their beauty, they uniformly cursed them for their density and the difficulty of penetrating the thickets. To again quote Thomas Lewis' 1746 journal: ". . .ye Lorals Ivey & Spruce pine [Hemlock] so Extremly thick in ye Swamp through which this River Runs that one Cannot have the Least prospect Except they look upwards. . . Such thickets of Loral to Strugle with whose Branches are all most as Obstinate as if composed of Iron. . . . Never was any poor Creaturs in Such a condition as we were in nor Ever was a Criminal more glad By having made his Escape out of prison as we were to Get Rid of those Accursed Lorals." (D.B.B.)

11

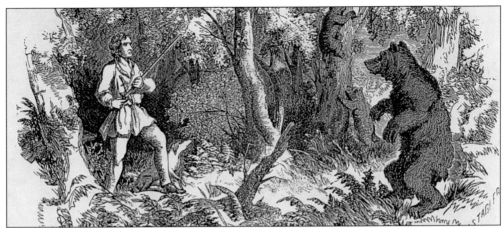

BEAR. This engraving by Edward Stabler was created to illustrate Meshach Browning's 1859 book *Forty-four Years of the Life of a Hunter*. The book details Browning's life in western Maryland where he killed about 2,000 deer, 400 bears, 50 pumas, and many wolves and bobcats. Browning must have felt some remorse for the incident illustrated since he justified killing the mother and her cubs as payback "for every trespass they made on me." These trespasses were the taking of occasional pigs. Bears were extremely common until the middle of the 19th century. Then, with improvements in weapons and increasing hunting pressure, bears nearly disappeared. Only now, 150 years later, with the protection of game laws and the restoration of habitat bears have once again become relatively common along the western reaches of the Potomac and are even occasionally seen in the outer suburbs of the Washington metropolitan area. (Br.)

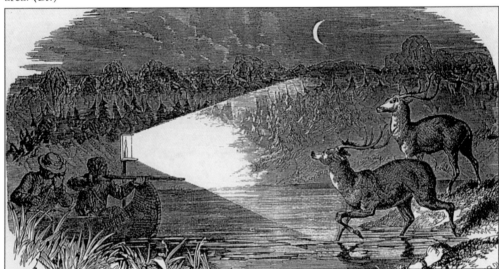

DEER. This, another Stabler engraving, depicts the somewhat romanticized white-tail deer. Today, a pest to gardeners and a menace to motorists, they were almost extirpated from the basin through over-hunting and habitat destruction. By 1900, it is estimated that there were no more than 500,000 deer in the entire U.S. Today, there are over twice as many animals in the states of Maryland and Virginia alone. When the Shenandoah National Park was created in 1936, there were no deer in the area that was to become the park. Thirteen animals were imported to establish a herd that today numbers over 5,000. Deer have become so numerous in the upper basin that residents refer to them as "Mountain Maggots." (Br.)

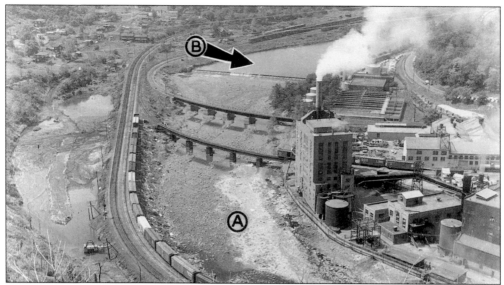

LUKE, THEN. This 1957 newspaper picture of the Westvaco Corporation's paper mill at Luke, Maryland, reflects the period of remorseless utilization of the river. The riverbed in front of the plant marked "A" is dry as a result of drought and the fact that the plant drew 60 million gallons daily from the impoundment behind the dam marked "B." All of the North Branches water passed through the plant and was released into the river below the factory carrying industrial wastes. Today, Westvaco is a good environmental neighbor, having not only cleaned up its act, but also joining in most watershed-wide cooperative efforts to improve the river for all basin residents. (MLK – 4499.)

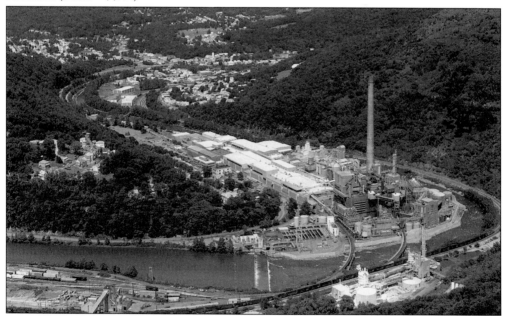

LUKE, NOW. As can be seen in this contemporary photograph, the Wesvaco plant at Luke now not only cleans up the water it uses, but also allows a reasonable amount of water to sustain the ecology of the river to pass the plant. The photograph also reflects the amount of development in this part of the Upper Potomac Valley in the past 40 years. (WCo.)

BLACK WALNUT. This valuable timber tree is still relatively common in the basin. West of the Allegheny Mountains it has been virtually exterminated. A slow-growing tree, it requires at least 80 years to reach a harvestable size. In addition to its tasty nuts and timber, the inner bark was used by both the Native Americans and the early European settlers as a laxative and a tonic. It was used to treat all sorts of ills including rheumatism, arthritis, headaches, dysentery, constipation, and wounds. (Trees.)

CARDINAL FLOWER. A deep cardinal red flower on a muddy bank is sure to gain your attention. The nectar of the cardinal flower is often the target of the long, slender bill of the humming bird. Some bees avoid the duty of pollen carrying by cutting a slit at the base of the flower and securing its nectar in this manner. This flower blooms July through August on muddy flats at the water's edge. (B.)

SCARLET OAK. One of the world's most beautiful oaks, the Scarlet Oak is found throughout the basin. This is the official tree of the District of Columbia. In the fall, it merits its name by turning a scarlet, much more intense red than any of the other oaks. (L.)

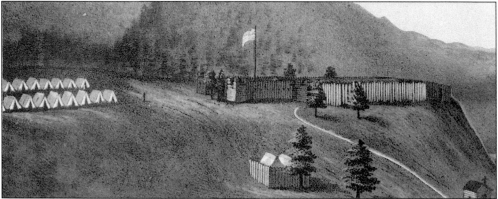

FORT CUMBERLAND. In the mid-18th century, while France and England struggled for a North American empire, this spot played a significant role. In 1749, King George II chartered the Ohio Company of Virginia with a mandate that gave the Company 200,000 acres of land in the Ohio Valley, if they settled 100 families there within seven years and if the company built a fort for the settlers' protection. The lieutenant governor of Virginia sent 21-year-old Adjutant George Washington to find the French and warn them away from the Virginia land along the Ohio River. Washington passed through the Wills Creek settlement, in both directions, and recognized its strategic importance. The governor, impressed with Washington's actions and report, promoted him to major and sent him back across the Alleghenies to expel the French. Washington's defeat prompted England to send a regular army under Maj. Gen. Edward Braddock to destroy the French. Preparatory to Braddock's arrival, a Col. James Innes was ordered from North Carolina to build a fort at Wills Creek. He called his defenses Fort Mount Pleasant. When General Braddock arrived, he changed the name to Cumberland in honor of his commander, William Augustus, Duke of Cumberland. After Braddock's defeat and death, the army retreated to Fort Cumberland. This postcard shows an artist's conception of the fort. It was produced in the mid-1950s in honor of Cumberland's bi-centennial. (MHS — pp22.)

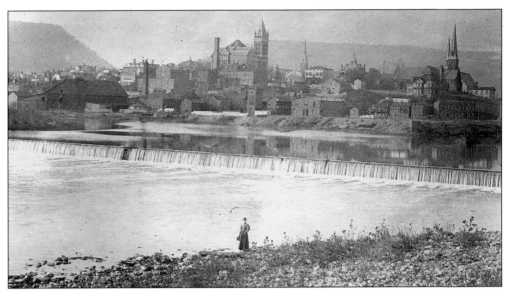

CUMBERLAND, MARYLAND. This turn-of-the-century photograph displays the industrial city of Cumberland from dam number seven on the Potomac River. Over the years, it has had more than its share of names. First called Wills Creek for a friendly Native American who remained in the small European settlement, it was later called the New Storehouse when the Ohio Company established a large ware- and storehouse there; Charlottesburg by the Ohio Company; Fort Mount Pleasant by Col. James Innes; Fort Cumberland by Gen. Edward Braddock; Washington Town in 1785 by the residents; and finally, in 1787, an act of the Maryland legislature officially changed the name to Cumberland. (MSA — Merrick-SC1477-5135.)

CUMBERLAND, 1861. By the coming of the Civil War, Cumberland would again take on strategic importance. It represented Washington's and the Industrial Northeast's access to the coal of Western Maryland and West Virginia. It was also the terminus of the Chesapeake and Ohio Canal and an important stop on the national road and the Baltimore and Ohio Railroad. This 1861 photograph was taken at the "Lime Kiln" on the Potomac River, looking upstream toward Cumberland. (MHS – 126.)

EASTERN RED CEDAR. This tree should more properly be called the Virginia Juniper. It is a typical Juniper, adapted to periodic drought; it has scale-like leaves and is commonly found on dry, sterile hillsides. The wood is used for fence posts. Sprigs of Juniper were, in former times, thrown into the fire to ward off evil spirits. The oil from leaves and fruit was used medicinally. (W.)

SHALE BARRENS. The Paw Paw Bends are caused by the wrinkling of the earth in the ridge and valley region. Another phenomenon created by this landform are the shale barrens. These mini-deserts are caused by aridity resulting from low rainfall, combined with the perfect drainage resulting from the broken shale substrate. The prevailing rains are from west to east; the clouds loose their moisture on the side of the ridge where the cloud is rising. Thus, the east side of the ridge tends to be the dry side. These barrens only get well watered when a tropical storm approaches from the southeast. The plants of these barrens have the same water-saving adaptations as desert plants: hairy, scale-like, fleshy leaves, or leaves modified to spines as in cactus. Red Cedar or Virginia Juniper is a typical tree of the barrens. (NW.)

17

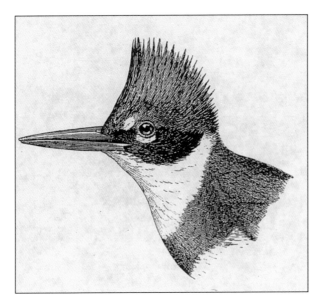

BELTED KINGFISHER. This relative of the woodpecker will probably first be detected by its loud, rattling call. It is a beautiful blue and white bird; the female has a rust colored band across her belly. They either sit on a prominent perch or hover over the river, watching for fish, or patrolling their territory along the river banks, frequently following paddlers for quite a way before breaking off and returning to their favorite perch. They can be seen on the Potomac year round. (M.)

ASSOCIATE JUSTICE SANDRA DAY O'CONNOR. Kayaking on the Potomac River has become very popular with residents upstream and downstream. In the summer of 1999, Associate Justice Sandra Day O'Connor took her clerks for an outing on the Paw Paw Bends. The young man in the rear of Justice O'Connor's kayak is Paul Palagyi of Atlantic Kayak Company. (NW.)

WESTERN MARYLAND RAILROAD. This bridge represents the abandoned route of the Western Maryland Railroad. It was chartered in 1853 by Baltimore Interests as a competitor to the Baltimore and Ohio Railroad in an attempt to lower coal prices. The Civil War delayed construction, but the line reached Hagerstown by 1872 and served Cumberland, by means of the C&O Canal to Williamsport, by 1876. In 1913, the WMRR built a fine, large station in Cumberland. Unlike the B&O, which, after Harpers Ferry, stays on the West Virginia bank of the Potomac, the WMRR cuts across the Paw Paw Bends by repeatedly crossing the river. The last trains used this bridge *c.* 1977. (NW.)

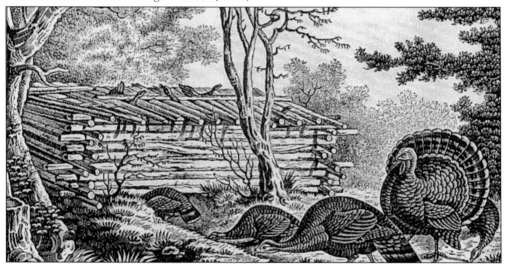

WILD TURKEY/WOODMONT. If, in the winter, you look up through the trees on the Maryland shore, you will see a fieldstone—the arts and crafts style clubhouse. This is the Woodmont Rod and Gun Club. This private hunting and fishing club, founded in 1881, was sold to the state of Maryland in 1995. Originally 2,023 acres, the club continued to acquire land; today, the state controls about 3,500 acres. The first club house was a typical Victorian frame resort built in the first year and destroyed by fire in 1903. After a 1909 reorganization, this building was replaced by a temporary lodge and, in 1929, was succeeded by the "permanent" clubhouse that stands today. Six presidents have visited Woodmont. Rather than attempting to maintain the preserve on an inadequate public budget, the Maryland Department of Natural Resources leases the clubhouse and 1,500 acres to the Isaac Walton League during hunting season. When the wild turkey, North America's largest game bird, had become virtually extinct in the eastern U.S., it was this club that undertook to breed the remaining birds and to reintroduce them to their former range. Today, the wild turkey population is greater than when Europeans arrived. (ATR.)

19

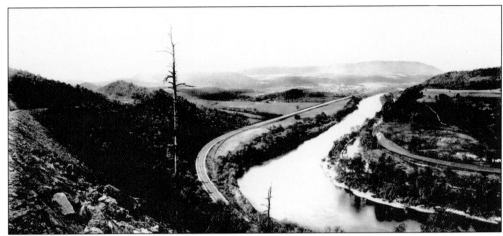

GREAT CACAPON, WEST VIRGINIA. This early photograph was taken looking southwest from Cacapon Mountain across the Cacapon valley; the town of Great Cacapon is in the right middle distance, in front of Tonoloway Ridge. On the skyline, you can see Sideling Hill. What is most impressive about this photograph is the almost denuded landscape. Today, this stretch of the river, through the ridges and valleys is heavily wooded. On the left of the river, in West Virginia, are the Baltimore and Ohio railroad tracks, now the Amtrac right-of-way. On the right of the river are the now abandoned Chesapeake and Ohio Canal and the Western Maryland Railroad tracks. (MHS.)

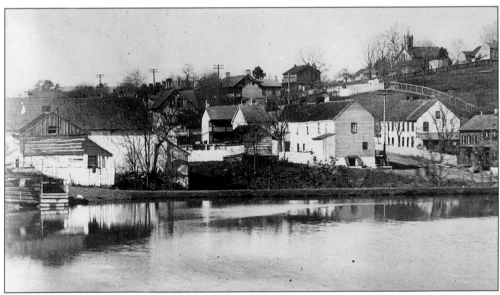

HANCOCK, MARYLAND. This turn-of-the-century photograph of Hancock shows the orientation of the typical Canal town. (MSA — Merrick-SC1477-5136.)

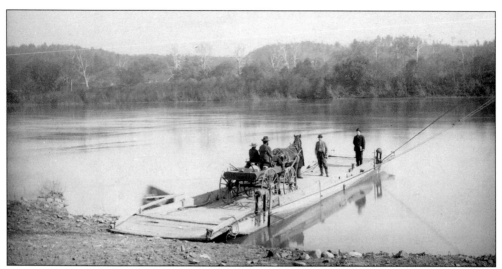

BERRY FERRY NEAR HANCOCK, MARYLAND. These two late-19th-century views show the river crossing near Hancock. The crossing was still by means of a rope ferry (the next step from fording the river). (MHS&MSA — Merrick-SC1477-5157.)

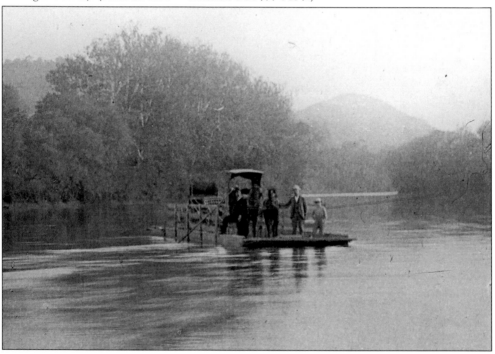

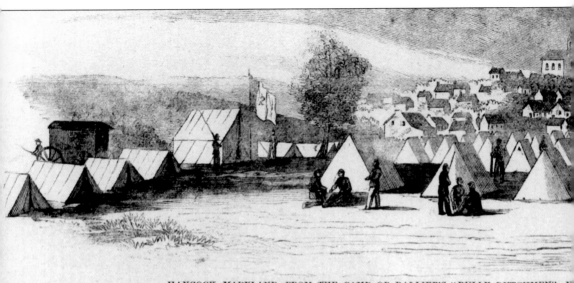

HANCOCK, MARYLAND, FROM THE CAMP OF BALLIER'S "BULLY DUTCHMEN"—N

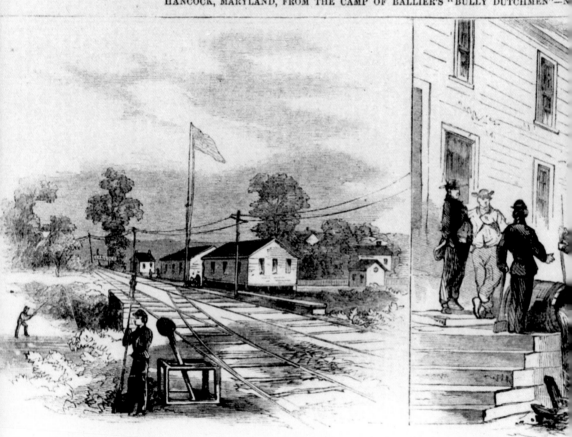

BALTIMORE AND OHIO RAILROAD STATION AT HANCOCK.

PENALTY OF SELLI

HANCOCK, MARYLAND. This 1862 illustration of a Civil War encampment at Hancock from *Harper's Weekly* shows a thriving community based on transportation. By the mid-19th century,

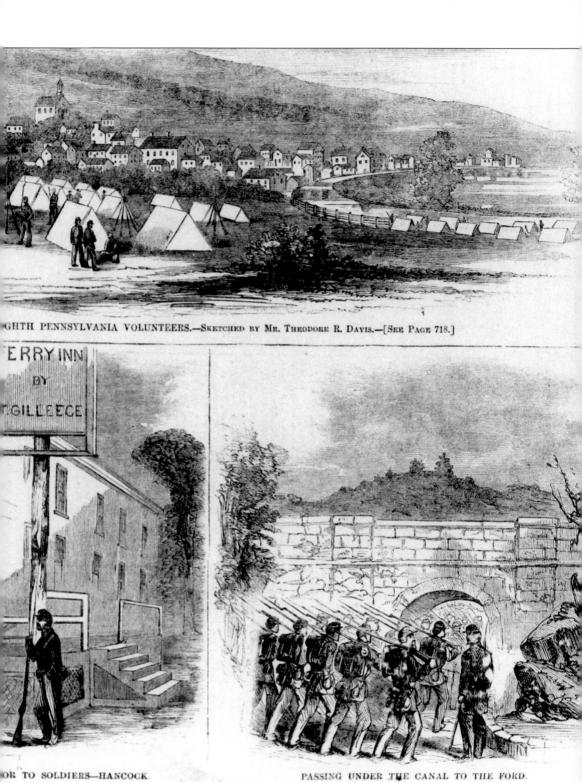

GHTH PENNSYLVANIA VOLUNTEERS.—Sketched by Mr. Theodore R. Davis.—[See Page 718.]

ERRY INN BY GILLEECE

OR TO SOLDIERS—HANCOCK.

PASSING UNDER THE CANAL TO THE FORD.

Hancock had not only the river, but also the Chesapeake & Ohio Canal, the National Road, and the Baltimore & Ohio Railroad. (FtWd.)

23

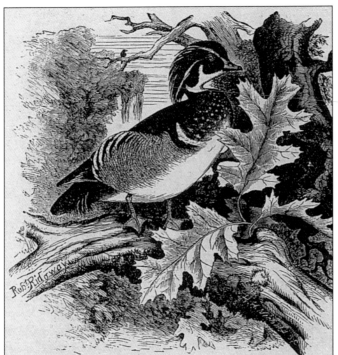

WOOD DUCK. These perching ducks nest in hollow trees or in artificial nest boxes put out to increase their numbers. They can be found along the Chesapeake and Ohio Canal, or in quiet water along the river. The females are protectively colored, unlike the brilliantly colored males. (K.)

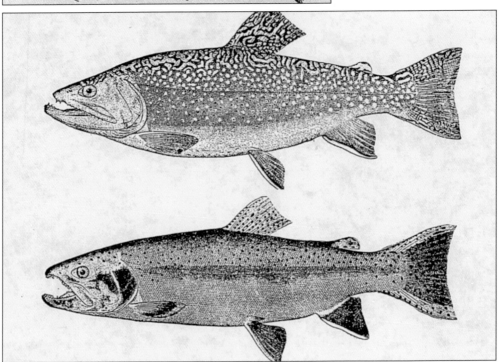

TROUT. The Brook Trout (top) is the native trout of the Potomac drainage. Most of its original range is no longer suitable for its survival, but there are breeding populations on many of the tributaries of the main river. The Rainbow Trout (bottom), introduced from the Western U.S., is much more common. (J.)

Two

THE UPPER POTOMAC
TONOLOWAY CREEK TO HARPERS FERRY

UPPER POTOMAC. This stretch of the river represents the western frontier of European settlement for the colony of Maryland in the mid-18th century, during the time of the French and Indian War. To protect the settlers from the French, Gov. Horatio Sharpe caused a permanent stone fort to be built at Big Pool (an old bed of the river) after Braddock's defeat in 1755. During the late-18th century and through most of the 19th century, the Upper Potomac had a high concentration of water-oriented industry, including mills that ground materials as diverse as cement and grain, sawed timber and stone, turned and shaped wood and iron, and wove cotton and wool; furnaces; forges; mines; and quarries. It terminates in one of America's greatest industrial complexes of the 19th century—Harpers Ferry. All of this industry, coupled with transportation parallel and across the river, made this area and a primary theater of the Civil War. (DH.)

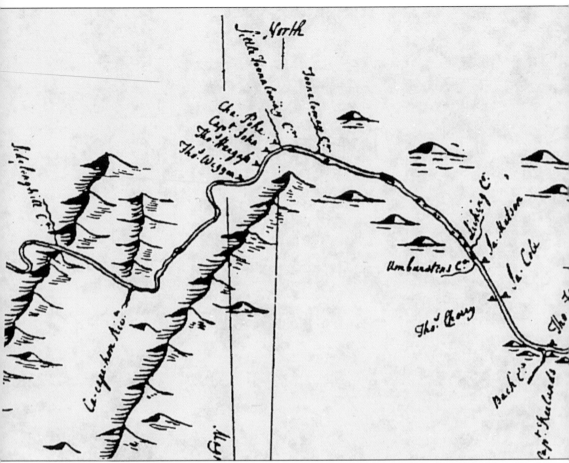

TONOLOWAY CREEK. This detail of Benjamin Winslow's 1736 map of *A Plan of the Upper Part of the Potomack River* shows the Tonoloway Creek section of the river just east of present-day Hancock. The landowners of the area include Charles Polke, here indicated as Cha. Poke (remarkably close for the time). The name in Ulster had been Pollock or Pollok and was variously spelled in the North American colonies: Polk, Poak, Poke, Pulke, Pock, and Bock. As early as 1721, Charles Polke was a well-known "Indian trader" who extended hospitality to those who traveled Conestoga Path west along the Potomac's North Bend. These travelers included missionaries, explorers, traders, and surveyors. The teen-age George Washington recorded the following in his journal for March 20 and 21, 1747:

> *Sonday* 20th finding y. River not much abated we in y. Evening Swam our horses over and carried them to Charles Polks in Maryland for pasturage till y. next morning.
>
> *Monday* 21st We went over in a Canoe and travell'd up Maryland side all y. Day in a Continued Rain to Collo Cresaps right against y. mouth of y. South Branch about 40 Miles from Polks I believe y. Worst Road that ever was trod by Man or Beast.

This little settlement at the Potomac's North Bend would eventually become Hancock. (Wi.)

EAST OF HANCOCK, MARYLAND. This early-20th-century view from West Virginia, with the Baltimore and Ohio tracks and one of the many Potomac Islands in the foreground, shows the area just east of Hancock. Two of the large farmhouses associated with the peach orchards (for which Hancock is famous) can also be seen. The first experiments with peach growing in western Maryland were in 1875 in Edgemont, just west of Frederick. By 1890, there was a major shift in growing from the Eastern Shore's Worcester County to western Maryland. (MHS.)

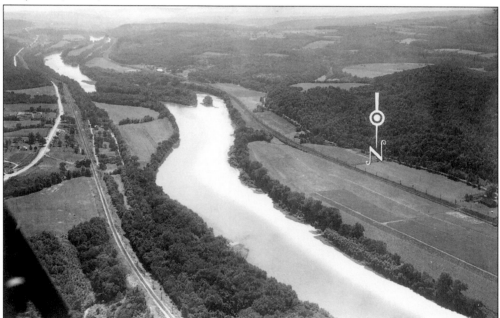

EAST OF HANCOCK. This 1958 photograph from the *Evening Star* illustrates visible mud pollution in the Potomac before the current controls on runoff. The *Evening Star*'s caption reads, "The light-colored belt hugging the far (West Virginia) shore of the Potomac River near Hancock, Md., is not clear water or bright sunlight. It is tan-colored mud emanating from a sand washery [sic] on a Potomac tributary [Warm Spring Run] near Berkeley Springs W. Va." Such pollution is lethal to all aquatic life. (MLK.)

SYCAMORE. No tree is more typical of the riparian (riverside) forest than the sycamore. Its mottled white and gray bark on the younger trunks makes it also one of the easiest trees to identify. In Europe, this tree is called the plane tree. A smaller cousin, the London plane tree, is one of the most popular street trees for urban areas with air pollution problems. The sycamore supplied the wood of choice for oxen yokes. (Trees.)

TRUMPET CREEPER. In late summer, in sunny spots throughout the basin, the bright orange trumpet of these native vines brings the edge of the woods to life. (B.)

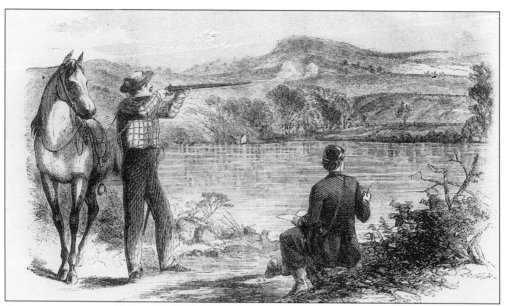

ACTION ACROSS THE POTOMAC. Early in the Civil War, as this 1861 illustration from *Harper's Weekly* depicts, there was a great deal of sniping at pickets across the Potomac, where it was narrow enough. Later in the war, this was discontinued as unchivalrous behavior. This engraving is interesting in that the artist depicts himself in the scene. (FtWd.)

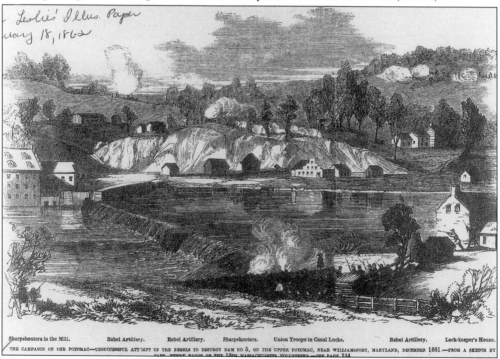

Leslie's Illus. Paper
may 18, 1862

Sharpshooters in the Mill. Rebel Artillery. Rebel Artillery. Sharpshooters. Union Troops in Canal Locks. Rebel Artillery. Lock-keeper's House.
THE CAMPAIGN ON THE POTOMAC—UNSUCCESSFUL ATTEMPT OF THE REBELS TO DESTROY DAM NO 5, ON THE UPPER POTOMAC, NEAR WILLIAMSPORT, MARYLAND, DECEMBER 1861.—FROM A SKETCH BY

ACTION AT DAM NUMBER FIVE. Dam number five is located about 5 miles up river from Williamsport. The canal was dependent on dams across the river to supply water. Since the Chesapeake and Ohio Canal represented a major east-west transportation link for the Union, there were repeated attempts to disrupt the canal throughout the war. (MLK – 7131.)

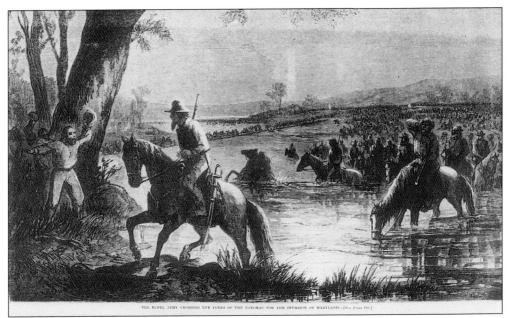

THE REBEL ARMY CROSSING THE FORDS OF THE POTOMAC FOR THE INVASION OF MARYLAND.—[See Page 614.]

REBEL DEPREDATION TO THE CANAL. The front-page headline for Saturday, July 30, 1864, in *Harper's Weekly* was "THE REBEL INVASION OF MARYLAND." The article spoke of "devastation," "desolated homes," "empty roosts and stables," and "broken communications." This havoc was caused by the raid of the troops of Confederate generals Jubal Anderson Early and John Cabell Breckinridge after their July 11th attack on Washington. The damages to the canal and the railroad were minor, and this would prove to be the last invasion of the Confederate forces into Union territory. (FtWd&MLK – 8198.)

POISON SUMAC. This highly toxic shrub to small tree is found in wet ground throughout the basin. It poisons in the same way as its close relative, poison ivy, by direct contact with the skin. Since the poison is an acid oil, the best treatment is also the same — wash as soon as possible with a slightly alkaline soap. (W.)

BLACK WILLOW. Growing in thickets along the river, the bark of this common plant supplied us the active ingredient of one of our most important medicines, aspirin. The chemical salicylic acid was not synthesized in the laboratory until 1890. (L.)

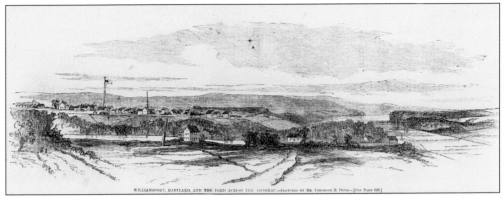

WILLIAMSPORT, MARYLAND. This view of Williamsport in 1862 depicts a rather pastoral scene, far from the conflict of war. Williamsport remains one of the purest canal towns along the Chesapeake and Ohio Canal; the national road missed it to the north and the railroads never had a major impact. It was intended to be a major city, as you can see from the super-wide streets. There is a myth that the reason they are so wide is because George Washington promised the townspeople that Williamsport would be the nation's capital if only they built wide streets. The problem with the story is that the streets were laid out in 1787 and Washington didn't visit on his trip seeking a site for the federal city until 1790. (FtWd.)

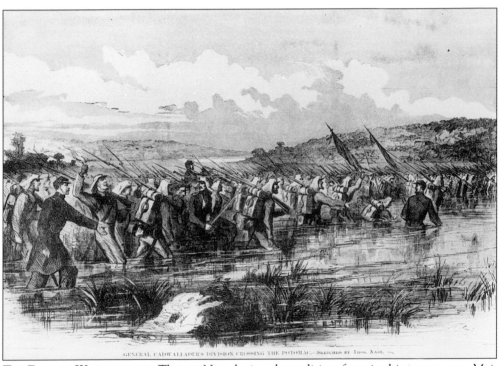

THE FORD AT WILLIAMSPORT. Thomas Nast depicts the realities of war in this same area as Maj. Gen. George Cadwalader led his Pennsylvania troops across the Potomac. He was on his way to join Maj. Gen. Robert Patterson in his unsuccessful effort to pin down Confederate Brigadier Gen. Joseph E. Johnston in the Shenandoah Valley and prevent Johnston from reinforcing Confederate forces at the first Battle of Bull Run. (FtWd.)

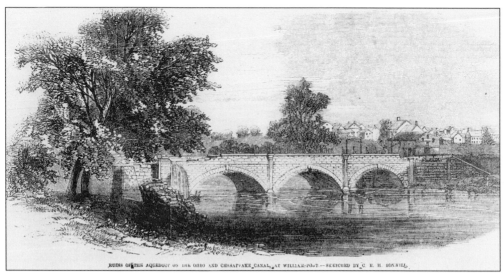

AQUEDUCT AT WILLIAMSPORT. Ironically, rivers and streams represented barriers to the canal. Bridges had to be built to carry the canal water over the intervening water barrier. These bridges were called aqueducts and represented some of the vulnerable points on the canal. Here, as depicted in *Frank Leslie's Illustrated Newspaper* for August 1, 1863, the rebels have successfully ruptured the aqueduct across the Conococheague Creek. While today it is much the worse for weather, it still stands. (MLK.)

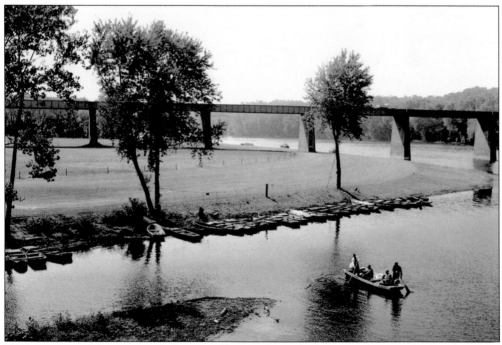

WILLIAMSPORT, MARYLAND. Today, the Chesapeake and Ohio Canal and its loading basin are re-watered at Williamsport. This 1962 photograph shows the boats available in Potomac River Park, part of the C&O Canal National Historical Park. (MHS — B1247.)

33

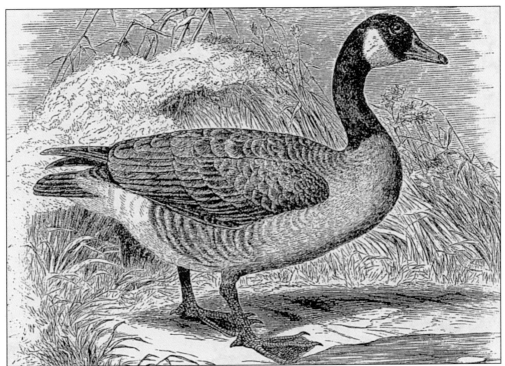

CANADA GOOSE. Certainly our most common and familiar goose, the Canada Goose can be found throughout the basin in both resident and migratory populations. In some park areas, they have become so numerous that they are considered a pest species. (K.)

POISON IVY AND BOX-ELDER. These two plants grow throughout the basin and are frequently confused. The old name for Box-elder, Ash-leaved Maple, certainly tells more about its appearance and relatives. The young leaves of Box-elder are in threes as are those of Poison Ivy, however, unlike Poison Ivy, there are usually some older leaves present on the Box-elder that have more leaflets than three. The leaves of Poison Ivy are glossy while those of Box-elder have a matte finish. (D&L.)

MONARCH BUTTERFLY.
This prominent species of butterfly will stand for all the species found in the Potomac Basin. Since the larvae of the Monarch feed on Milkweed, the adults can frequently be found around this plant. These butterflies are unusual in that they migrate south each fall. (JKH.)

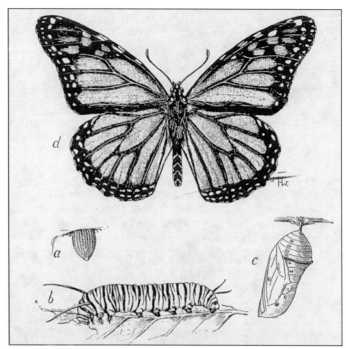

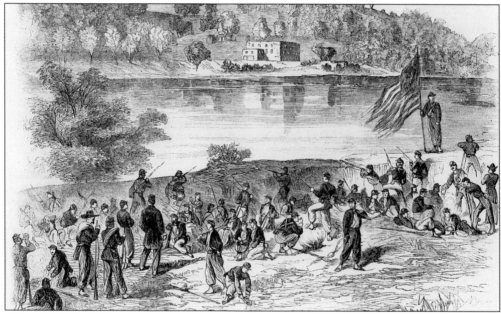

EARTHEN WORKS ON THE MARYLAND SHORE. One of the most famous fords across the Potomac was Packhorse Ford, about a mile downstream from Shepherdstown. In the 1720s, German, Irish, and Scotch-Irish settlers from Pennsylvania and Dutch settlers from New York moved into the Shenandoah Valley of Virginia. They followed the old Indian trail south from York, Pennsylvania, to cross the Potomac at Packhorse Ford. This ford has also been known as Blachfords, Botelers, Shepherdstown, and Wagon Road Ford. Here, in a late 1862 illustration from *Harper's Weekly*, you see the Union Army defending that ford. The strange looking, bloomer-like uniforms indicate that the defenders belonged to a Zouave unit. (FtWd.)

JAMES RUMSEY MEMORIAL BRIDGE. The James Rumsey Memorial Bridge was opened across the Potomac at Shepherdstown, West Virginia, on July 15, 1939. The new bridge is depicted on this picture postcard. The bridge honors Shepherdstown's most famous son, James Rumsey, who on December 3, 1787, tested his steamboat in the Potomac opposite Mecklenburg, Virginia. The boat was powered by a jet of water propelled out the stern by a steam force pump. The bridge, destroyed during the Civil War, was rebuilt in 1871, only to be destroyed by flood in 1889. Another replacement bridge was destroyed by the 1936 flood and temporarily replaced by a ferry until the bridge pictured was opened. (MHS — pp22.)

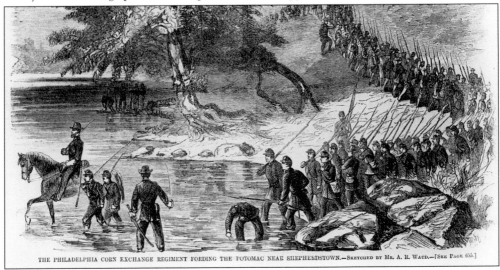

THE PHILADELPHIA CORN EXCHANGE REGIMENT FORDING THE POTOMAC NEAR SHEPHERDSTOWN.—SKETCHED BY MR. A. R. WAUD.—[SEE PAGE 655.]

SHEPHERDSTOWN, WEST VIRGINIA. In 1734, Thomas Shepherd founded Mecklenburg, Virginia (now West Virginia). from the first it was popularly called Shepherdstown. This was an important crossing of the Potomac. Initially a ford, then a ferry called first Van Swearingen's ferry and later Blackford's, the crossing finally became the James Rumsey Memorial Bridge. When Thomas Van Swearingen established a ferry across the Potomac in 1765, Mecklenburg maintained a road on the Virginia side leading to the ferry landing; Frederick County (now Washington County) maintained a road from Boonsboro through Sharpsburg to Swearingen Landing. Virginia finally changed the name of Mecklenburg to Shepherdstown in 1798, to conform to the popular practice. High on a hill on the Maryland bank stands Ferry Hill, now the headquarters of the Chesapeake and Ohio Canal National Historical Park, but historically the home of the Douglases. They were the owner/operators of the ferry and the bridge. In 1861, Company B of the 2nd Virginia Infantry, Confederate States of America, burned the covered bridge across the Potomac River at Shepherdstown. One of the enlisted men was Henry Kyd Douglas of Ferry Hill. After the war, Colonel Douglas recounted his experiences in *I Rode With Stonewall*. In this late 1862 illustration from *Harper's Weekly*, we see the Philadelphia Corn Exchange Regiment fording the river. It was not uncommon for regiments to be known by either the place where they were recruited or the organization that financially backed them. (FtWd.)

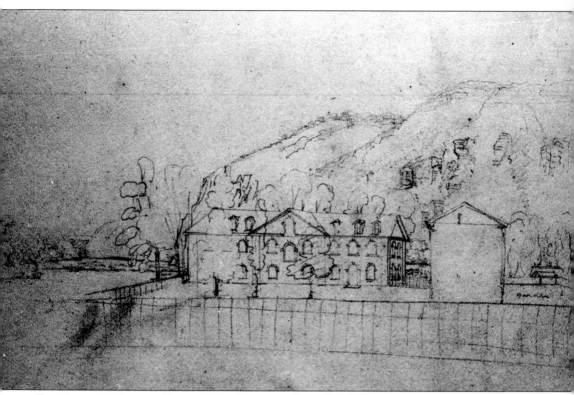

THE ARMORY, HARPERS FERRY, WEST VIRGINIA. Peter Stephens, the first permanent resident at the confluence of the Shenandoah and Potomac Rivers, established a trading post and an irregular ferry service between the Virginia shore (later Harpers Ferry, West Virginia) and Maryland in 1733. In 1747, Robert Harper bought Stephens' rights to what would become Harpers Ferry. After establishing the first U.S. armory at Springfield, Massachusetts, in 1794, President Washington designated Harpers Ferry as the second armory. Washington picked the site because of its unlimited water power and ready access to already thriving iron furnaces and forges. This rubbed, pencil drawing by Benjamin Henry Latrobe depicts the completed armory in 1810. Latrobe was an architect, born and educated in England; he came to America in 1796 and settled first in Philadelphia. President Thomas Jefferson named him surveyor of public buildings in 1803, thus bringing him to Washington. He remained in this area until after the War of 1812. (MHS — XI-17.)

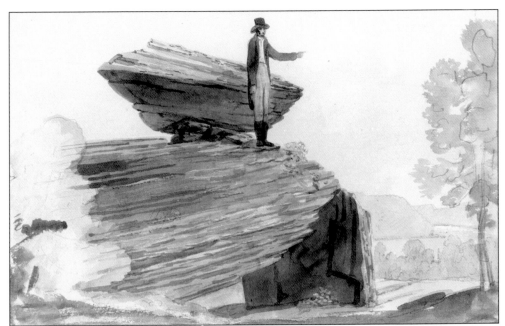

JEFFERSON'S ROCK. B.H. Latrobe captured Jefferson's Rock in watercolors on the same trip in which he sketched the armory. This rock was so named because it was here that Thomas Jefferson stood in 1783. He described the view in his 1785 *Notes on the State of Virginia* as, ". . .one of the most stupendous scenes in Nature. . . . This scene is worth a voyage across the atlantic." Like many other natural sites, this one was almost loved to death by tourists. The upper slap became so unstable that, between 1855 and 1860, it was necessary to support it with the four rock pillars, as seen in the early-20th-century postcard pictured below. (MHS — XI-15, pp22.)

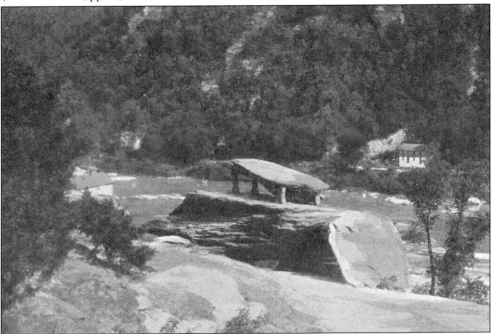

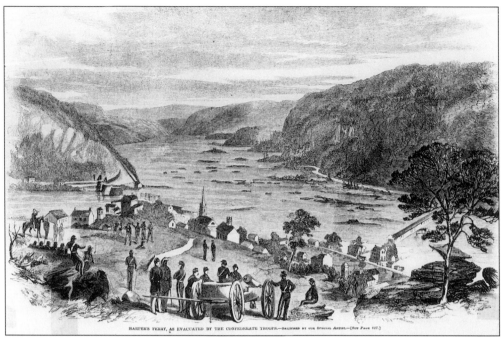

HARPER'S FERRY, AS EVACUATED BY THE CONFEDERATE TROOPS.—SKETCHED BY OUR SPECIAL ARTIST.—[SEE PAGE 427.]

HARPERS FERRY, WEST VIRGINIA. During the Civil War, Harpers Ferry changed hands four times. Due to raids the railroad bridge was destroyed and rebuilt nine times. This scene from *Harper's Weekly* depicts the first Confederate withdrawal on June 14, 1861. The rebels had blown up the railroad and wagon bridges and burned the principal musket factory workshops. The destruction of the bridges is shown below. (FtWd.)

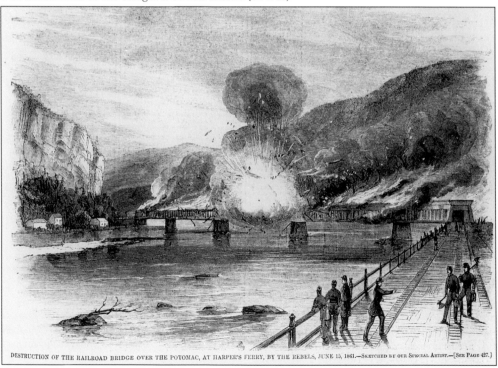

DESTRUCTION OF THE RAILROAD BRIDGE OVER THE POTOMAC, AT HARPER'S FERRY, BY THE REBELS, JUNE 15, 1861.—SKETCHED BY OUR SPECIAL ARTIST.—[SEE PAGE 427.]

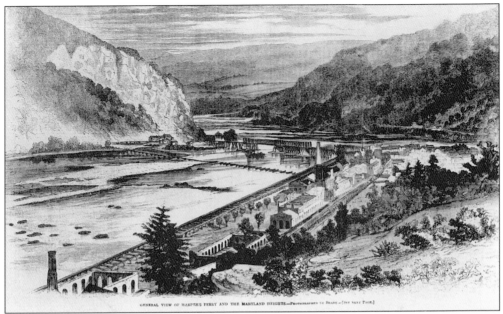

GENERAL VIEW OF HARPER'S FERRY AND THE MARYLAND HEIGHTS.—Photographed by Brady.—[See next page.]

HARPERS FERRY, 1862. Once the Union forces retook Harpers Ferry after the Battle of Antietam on September 18, 1862, it remained in Union hands for the remainder of the war. The rebuilt railroad bridge is shown in the background, with a pontoon bridge in the foreground. (FtWd.)

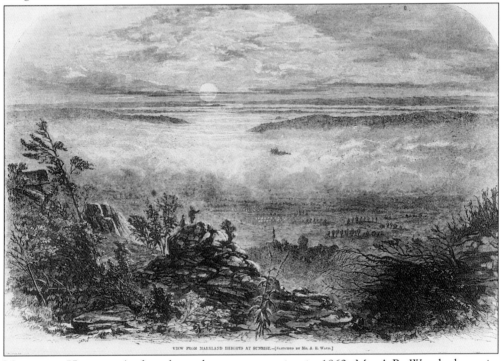

VIEW FROM MARYLAND HEIGHTS AT SUNRISE.—[Sketched by Mr. A. R. Waud.]

MARYLAND HEIGHTS. As fiercely as the war was raging in 1862, Mr. A.R. Waud, the artist for *Harper's Weekly*, took time out to appreciate the picturesque view from Maryland Heights, across from Harpers Ferry, at sunrise. (FtWd.)

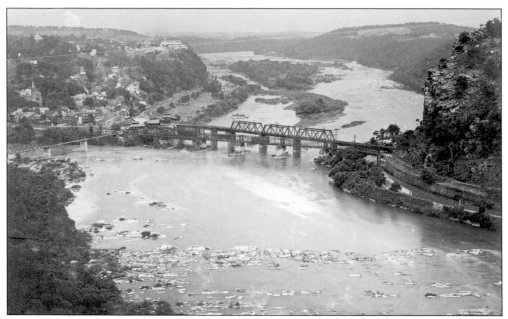

HARPERS FERRY, C. 1880. This photograph of a restored Harpers Ferry shows primarily a resort community rather than the industrial center it had been before the war. In the foreground is a Bollman truss bridge of the Washington County Railroad. (MHS — 224.484.)

HARPERS FERRY, 1958. In addition to showing the modern condition of bridges across the Potomac at Harpers Ferry, this photograph shows the light-tan waters of the Shenandoah flowing into the Potomac. This suffocating pollution was primarily from poor agricultural practices, which have since been alleviated. The stone piers of the old Washington County Railroad Bridge can be seen downstream of the intact railroad bridges. The bridge farthest upstream (to the right) still carries rail traffic. The middle bridge carries the Appalachian Trail across the Potomac. This approximately 1,250-mile-long trail was completed between 1930 and 1937. (MLK – 4501.)

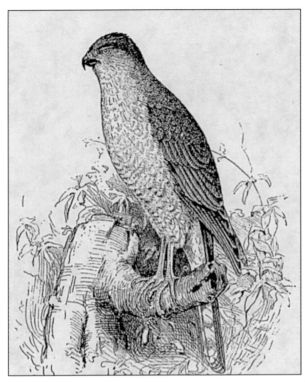

COOPERS HAWK. This woodland hawk has a long tail and short, rounded wings, which give great agility in flying through trees to catch its prey of small birds. Our area also has a smaller edition of this hawk, the Sharp-shinned Hawk. (M.)

SERVICEBERRY. One of the most charming sights at the forest edge in the early spring is this, frequently bare of leaves, large shrub or small tree covered in white blossoms. Called serviceberry in the elevated part of the basin because it bloomed coincident with the funeral services at the end of winter when the ground began to thaw, it is called shadbush or shad blow on the coastal plain, where its blooming season coincides with the migration of shad up river. (B.)

Three

THE UPPER POTOMAC
BRUNSWICK TO LITTLE FALLS

POTOMAC FROM MARYLAND HEIGHTS.
This etching of the Potomac River
from Maryland Heights appeared
in the 1874 *Picturesque America*.
It clearly shows the Chesapeake
and Ohio Canal and a canal
community. This spot has been
a transportation hub since before
European settlement. Here, the
valley at the base of the Catoctin
Mountains in Maryland meets
the valley at the base of the Blue
Ridge Mountains in Virginia at
the Potomac. It was first known as
either Buffalo Wallow, for migratory
Bison, or Eel Pot, for the weirs set in
the Potomac. John Hawkins began
operating a ferry here at a ford called
German Crossing, in 1741. In 1753,
he laid out a town and patented it
as "Merry Peep o' Day." By 1811, it
had a post office named Berlin; in
1832, the postal service changed the
name to Barry to avoid confusion
with Berlin in Worcester County,
Maryland; however, the citizens seem
to have continued to call it Berlin.
In 1890, the residents changed
the name to Brunswick. Certainly
the names suggest a large German
segment to the population. The ford
at Berlin remained an important
communication link between
the north and south throughout
the Civil War. (Kip – 905.)

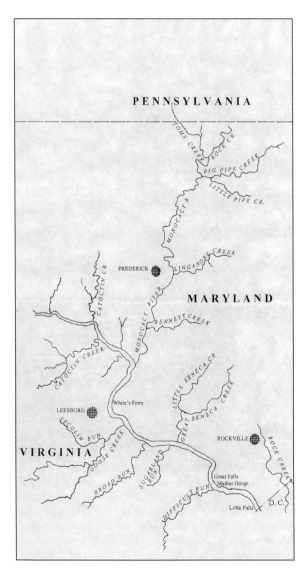

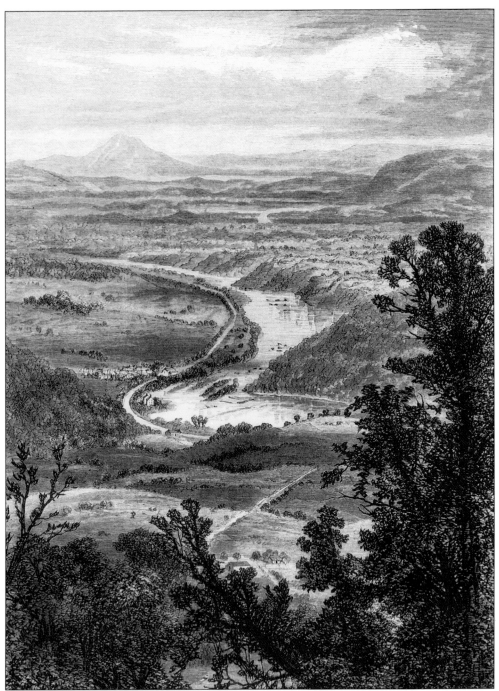

UPPER POTOMAC. Brunswick was laid out as "Merry Peep o' Day" in 1753; by 1811, it was a post office named Berlin; in 1890, the name was changed to Brunswick. Both Berlin and Brunswick reflect the strong German influence in this section of the valley. This segment, so close to the metropolitan district of Washington, incorporates some of the most rugged and thus the most scenic sections of the river. Much of the stone used to build both the city and the canal came out of quarries along this portion of the river. (DH.)

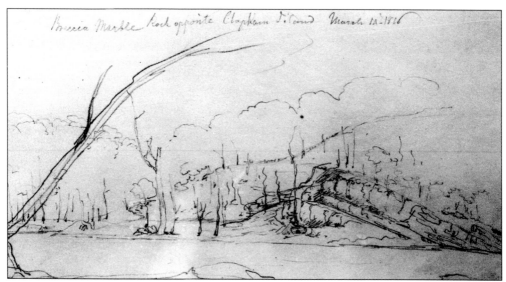

BRECCIA MARBLE. This pencil sketch by Benjamin Henry Latrobe is labeled in his sketchbook, "Breccia Marble Rock opposite Clapham Island." The building of public buildings in Washington included a constant search for suitable materials. On August 8, 1815, Latrobe wrote to the Commissioner of Public Buildings to inform him of his recent discovery of a new source of suitable stone: "There is on the S East of the Cotocktin [Catoctin] Mountain a very large extent of country, which abounds in immense Rocks of Marble, or Limestone <u>Breccia</u>, that is of a Stone consisting of fragments of ancient Rocks bound together by a calcareous cement, and thus becoming one solid and uniform (homogeneous) Mass of Marble. . ." (MHS — XIII-8.)

FAIRVIEW VILLAGE. Fairview is a lost village on the Baltimore and Ohio Railroad near Frederick, Maryland. Oliver Wendell Holmes Sr. wrote after traveling to Frederick to find his wounded son, "In approaching Frederic, the singular beauty of its cluster spires struck me very much, so that I was not surprised to find 'Fair—View' laid down about this point on a railway map." (FtWd.)

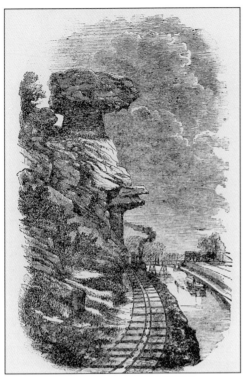

BOLLEMAN'S ROCK. This 1861 engraving shows how close the Baltimore and Ohio Railroad was to the Chesapeake and Ohio Canal at Point of Rocks, Maryland. This right-of-way was the subject of a protracted court battle between the B&O and the C&O from 1828 to 1832. This natural wonder, Bolleman's Rock, was destroyed by Confederate raiders in 1861. (FtWd.)

POINT-OF-ROCKS TUNNEL. The final solution of a railway tunnel at this point was not achieved until 1868 as shown in the photograph to the right, taken from a barge in the river in about 1870. (MHS.)

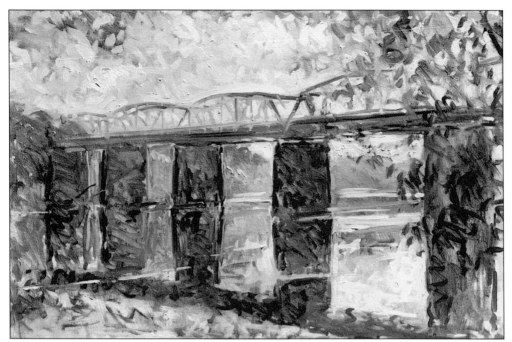

POINT-OF-ROCKS BRIDGE. In the 1840s, a bridge was constructed across the Potomac, connecting Point of Rocks, Frederick County, Maryland, with Loudoun County, Virginia. Since this provided a direct link between the agricultural areas of Virginia and the markets in Baltimore, the construction of this bridge spelled the doom of many of the old ferries across the Potomac. This bridge has been rebuilt many times. The painting above is of the 1990s bridge. It was painted by Michael Piecnocinsky, a contemporary impressionistic painter of scenes along the Potomac. Michael teaches art in Montgomery County schools and exhibits his work at the Veerhoff Galleries in Georgetown. (MP.)

HEATER ISLAND. In 1699, the Piscataway Indians, then known as Conoy, relocated to a new palisaded village, Canavest, on Heater's Island near the present-day Point-of-Rocks in Frederick County, Maryland. This 1956 photograph shows Heaters Island, one of the Potomac's largest islands, from Point-of-Rocks. This island now belongs to the State of Maryland and is potentially one of the richest archeological sites in the state. (MHS.)

DRAGONFLY. This generalized dragonfly is a stand-in for the many species found along the Potomac. Few activities are more interesting while lazily paddling than watching dragonflies hawk on mosquitoes and use their legs as a net in which to catch their prey. (JKH.)

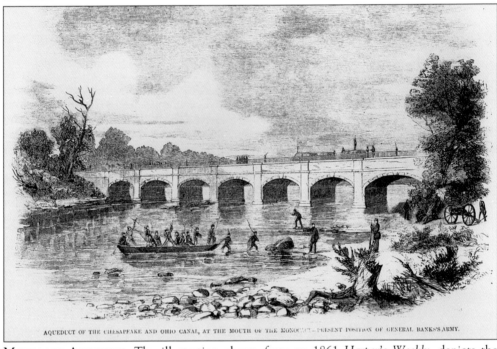

AQUEDUCT OF THE CHESAPEAKE AND OHIO CANAL, AT THE MOUTH OF THE MONOCACY—PRESENT POSITION OF GENERAL BANKS'S ARMY.

MONOCACY AQUEDUCT. The illustration above, from an 1861 *Harper's Weekly*, depicts the Chesapeake and Ohio Canal Aqueduct across the Monocacy River. Maj. Gen. Nathaniel P. Banks was encamped there to defend this important communication link. General Banks was the former governor of Massachusetts, thus the magazine's interest in where he was. He had been so unsuccessful against Maj. Gen. "Stonewall" Jackson in the Shenandoah Valley that he was called by the Confederates, "Commissary Banks," because of all of the supplies he lost. In 1959, the Historic American Building Survey described the condition of the aqueduct as "disintegrating." This beautiful aqueduct was constructed of pink quartzite from Sugarloaf Mountain in 1833. The rock was brought to the construction site by a wooden-railed railroad constructed for that purpose. This is one of the longest (560 feet) aqueducts along the 184.5 miles of the canal. The masonry was so well fabricated that it defied Confederate attempts to blow it up. Floods and time have been more successful; today, there is a citizens's committee to restore the Monocacy Aqueduct. (FtWd.)

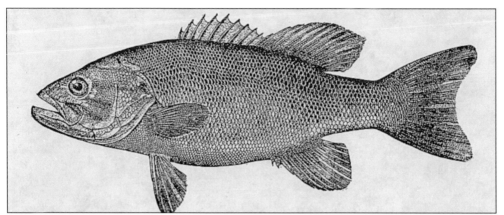

SMALLMOUTH BASS. What the Largemouth Bass is to the tidal Potomac, the Smallmouth is to the upper river. A very desirable game fish, it is sought by anglers of every persuasion. Insect hatches challenge the fly-fisherman to match his lure to the current hatch for stellar fishing. (J.)

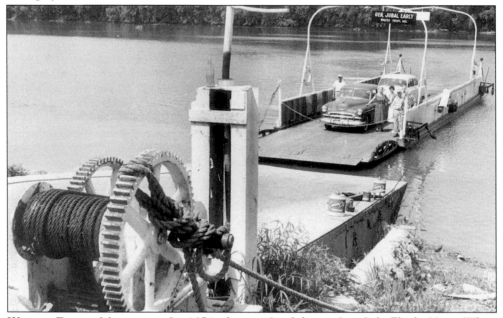

WHITES FERRY, MARYLAND. In 1871, former Confederate Lt. Col. Elijah Viers White re-established a ferry at this site (Conrad's Ferry had operated here since 1808). Before, it was a poled wooden barge, but now the rope guide had been replaced by a wire cable. White named the ferryboat for his former commander Maj. Gen. Jubal Anderson Early, who led a raid on Washington in 1864. In 1919, the motive force was changed from a man with a pole to a gasoline powered skiff. The flood of 1942 destroyed Whites Ferry. Due to wartime restrictions, no ferry operated until 1946, when the Williams family sold it to the Brown family, who still operate the ferry. This 1960 photograph shows the ferryboat (an army surplus wooden barge) before the current one named the *Jubal A. Early*. When the owner tried to once again name the boat the *Jubal Early*, he was told no two boats in Maryland could be registered under the same name so he added the "A." The contemporary boat is a steel barge that can carry eight automobiles and is powered by a small tugboat. This is the only active ferry still crossing the Potomac River. (MLK.)

VIEW FROM WHITES FERRY, BALL'S BLUFF, VIRGINIA. The Virginia embankment that is shown is Ball's Bluff, the site of a small battle on October 21, 1861, with immense consequences. Here, Confederate Elijah Viers White (of Whites Ferry) fought so well as a private that he was commissioned and authorized to raise an independent company for border service. The northern defeat was so unexpected and northern moral so shattered that Congress demanded a scapegoat. In an unfair investigation, unrivaled in U.S. history, the blame was placed on Brig. Gen. Charles Pomeroy Stone. Stone was arrested without charge and imprisoned for 189 days in New York Harbor. He was then released. He was never charged and never cleared. This perspective of this impressionistic painting by Michael Piecnocinsky is looking down river from Whites Ferry toward the Virginia shore. (MP.)

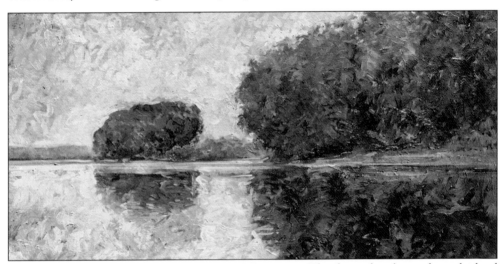

HARRISON ISLAND, MONTGOMERY COUNTY, MARYLAND. This large, low-lying, farmed island was the sight of Union entrenchment before the Battle of Ball's Bluff. They were covered by Union guns on the Maryland shore. This was to be the point for retreat if the force sent to Ball's Bluff encountered stiff resistance. Today, it is agricultural land in a bucolic setting, as depicted in this impressionistic painting by Michael Piecnocinsky. (MP.)

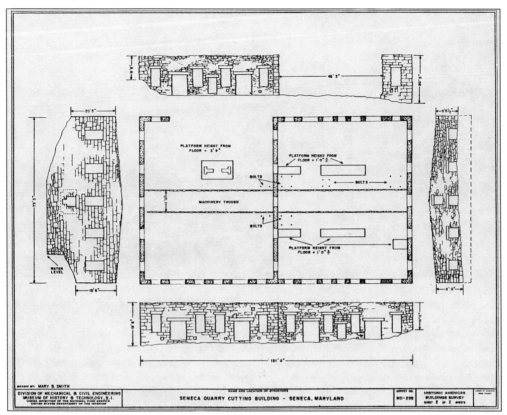

DIVISION OF MECHANICAL & CIVIL ENGINEERING
MUSEUM OF HISTORY & TECHNOLOGY, S.I.
UNDER DIRECTION OF THE NATIONAL PARK SERVICE
UNITED STATES DEPARTMENT OF THE INTERIOR

NAME AND LOCATION OF STRUCTURE
SENECA QUARRY CUTTING BUILDING - SENECA, MARYLAND

SURVEY NO.
MD-299

HISTORIC AMERICAN
BUILDINGS SURVEY
SHEET 2 OF 2 SHEETS

SENECA STONE CUTTING BUILDING. When one comes upon the ruins of this building in the spring or summer, when the vegetation is lush, one is reminded of nothing so much as of a Central American temple. In fact, the building was a stone cutting mill. It drew its waterpower from the canal in a trench in the center of the building. The water turned a wheel (later a turbine), which powered a toothless saw which cut stone at the rate of one inch an hour. The wastewater was spilled into Seneca Creek. The mill was completed in 1837; here, the stone was cut and polished for the Smithsonian Castle in Washington. (HABS.)

SWAINS LOCK NUMBER 21. Each lock raised the canal boats about eight feet; there were 75 locks to lift canal boats a total of 605 feet between tidal Georgetown and Cumberland. Lock 21 is named for the Swain family that has been associated with the Chesapeake and Ohio Canal since its construction. A member of the family still lives in the lock keeper's house at this lock. Here, he rents canoes and bicycles. This view of the river was painted by Andrei Kushnir, a landscape artist who paints directly from nature. The medium is oil on canvas. Andrei is represented in Washington by Taylor & Sons Fine Art. (AK.)

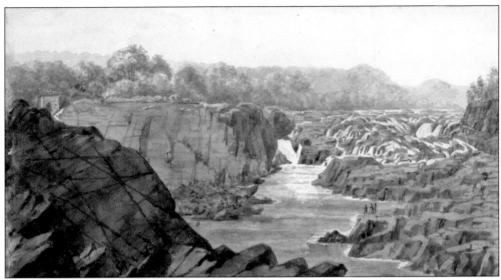

GREAT FALLS OF THE POTOMAC. Benjamin Henry Latrobe established the view point for painting the Great Falls when he rendered *View of the Great Falls of Potomac, Taken from a Rock on the South side* on September 15, 1809. Most artists seem to have agreed that this romantic view is more spectacular from the Virginia shore. Here, the Potomac descends about 40 feet in less than 200 feet into a narrow gorge less than 27 feet wide at some points. The hard rock that produced the falls is metagraywacke. This was originally a mixture of mud and sand deposited on the ancient sea floor. It has been changed over time (metamorphosed) by heat and pressure to produce a rock highly resistant to erosion. The 1874 engraving below, from *Picturesque America*, represents the romantic extreme. (MHS — XI-9, Kip – 2453.)

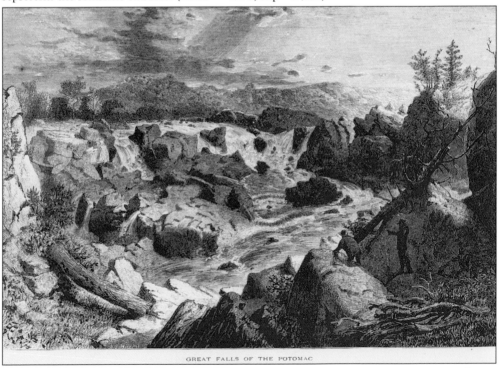

GREAT FALLS OF THE POTOMAC

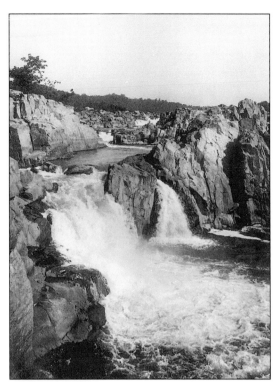

GREAT FALLS OF THE POTOMAC, VIRGINIA. This contemporary photograph of the Great Falls at normal water level illustrates its inspiration to artists, while the 1972 daredevil photograph below, taken after hurricane Agnes, illustrates the power of the falls at super-high water. (MLK — 5987, MC.)

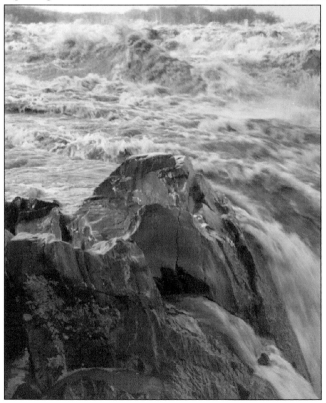

DROUGHT ROCK. The United States Department of Interior, Geological Survey has dubbed this large boulder in Mather Gorge "Drought Rock," since it only is viable during times of extremely low flow. This photograph, taken on September 10, 1966, shows the rock fully exposed on the day of the river's all-time low flow of about 388 million gallons per day (mgd). Today, the river flow is supplemented with water from up-river reservoirs to ensure adequate water supplies to the metropolitan area and at least a 300 mgd pass-by to protect the ecology of the river. (MLK – 4498.)

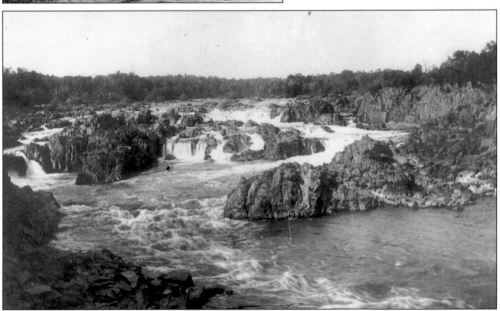

MATHER GORGE. This rugged gorge extends about 1.5 miles long, from the base of the falls to the south tip of Bear Island. It was named for Stephen Tyng Mather, the first director of the National Park Service. The cliff walls are about 66 feet high, while the river is about 209 feet wide and averages 26 feet deep. There is an 82-foot, northward displacement of the strata on the west side of the canyon indicating that this gully runs along a fault line, scouring out the crushed rock resulting from the faulting. (MLK – 5981.)

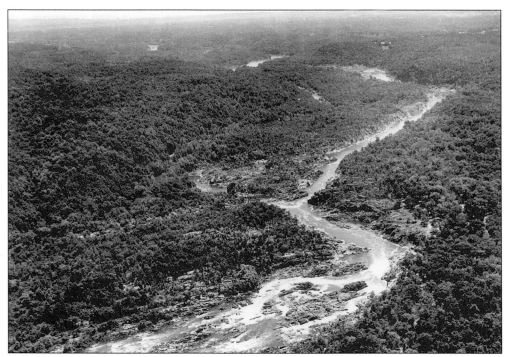

YELLOW AND STUBBLEFIELD FALLS. As the river widens out below Mather Gorge, it bifurcates around Turkey Island and then goes over a series of rapids. The rapids on the two sides of the island are called Yellow Falls, while the relatively wide field of rapids below the island is called Stubblefield Falls. (MLK.)

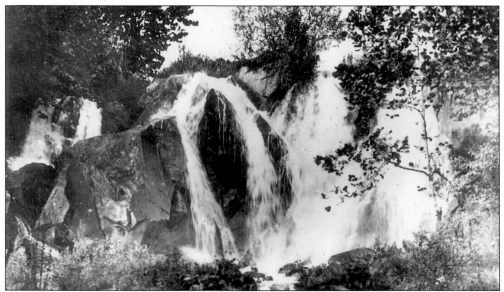

SCOTT RUN, FAIRFAX COUNTY, VIRGINIA. This beautiful little waterfall is typical of many of those found in the mouths of the small tributaries in this section of the Potomac. In the 1920s, Congress was considering a hydroelectric scheme to produce power for the District of Columbia that would have drowned all of these falls. In 1927, the plan was abandoned in favor of preserving the natural beauty of the Great Falls area. (MLK – 5956.)

COPPERHEAD. The Copperhead is the only venomous snake you are apt to encounter along the Potomac. While these are pit-vipers (like the rattle snake), they have no rattles and are much less venomous. The colors of the Copperhead are warm earth-tones that make it a perfect match for the fallen leaves. There are no Cottonmouth Water Moccasins this far north. The snakes that you do see in the river are most generally the harmless Northern Water Snake. (DNR.)

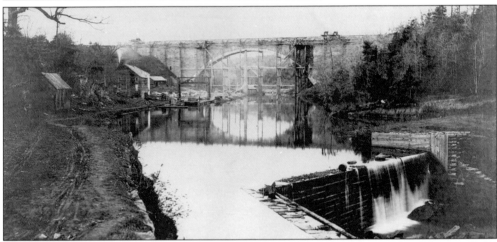

CABIN JOHN BRIDGE. On August 1, 1851, a fire broke out in the capitol. It destroyed the library and endangered the wooden dome. For years, there had been discussions of the need for a dependable, safe water supply for the nation's capitol. The fire mobilized Congress into authorizing a survey and the subsequent work to develop this supply. The 35-year old Lt. Montgomery Cunningham Meigs was tasked with solving this problem. With minor modifications, Washington D.C. is still using the system he built to supply Potomac River water to the metropolitan area. The most visible reminder of this monumental accomplishment is the Cabin John Bridge, constructed between 1857 and 1863, which still carries both water and traffic across Cabin John Creek. This 1861 photograph shows the creek's dam, which created a pool under the bridge site, thus allowing a connection with the Chesapeake and Ohio Canal through a specially constructed lock. The C&O then served as a means of transporting the building materials to this location. (Kip 4359.)

MAPLE. Many maples grow in the Potomac Basin. Of these, the Sugar Maple had the greatest impact on the European settlers. The area along the river in Montgomery County, Maryland, was known as "Sugar Land" because of the presence of so many maples. In earliest spring, when the sap began to rise, the trees were tapped for their sap, which was boiled down to reduce it to syrup and then to a crude sugar. George Washington noted in his journal for a cold morning in January of 1785: Road to my Mill Swamp, where my Dogue run [a stream entering the Potomac below Mount Vernon] hands were at work, and to other places in search of the sort of Trees I shall want for my walks, groves, and Wildernesses. . .some Maple Trees on high ground. . . ."(L.)

CABIN JOHN BRIDGE TABLET. This 1886 photograph of the completed bridge by Clifford Jones of the United States Geological Survey shows the dedication tablet in the upper left quadrant. The stone reads, "Washington Aqueduct, Begun AD 1853, President of the U.S., Franklin Pierce Secretary of War _____ Building AD 1861, President of the U.S. Abraham Lincoln, Secretary of War Simon Cameron." In the summer of 1862, Jefferson Davis's name was literally chiseled off the inscription. It was not until 1908 that Theodore Roosevelt ordered the stone recut, restoring Jefferson Davis's name. This may serve as an indication of the intensity and duration of the feeling in Washington against those who took part in the War of the Rebellion. (MLK – 1534.)

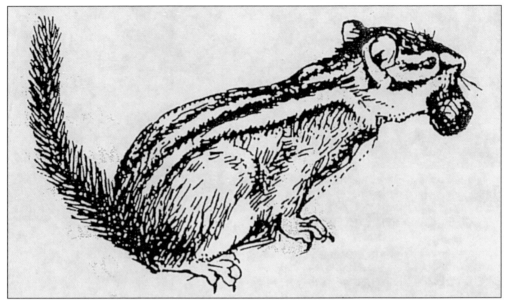

EASTERN CHIPMUNK. These diminutive, striped squirrels are always popular as they scamper over the rocks and the forest floor. The trees of the eastern forest supply an abundant crop of nuts for these foragers. In return, the Chipmunks plant replacements for the forest trees. (DNR.)

SYCAMORE ISLAND. Opposite the town of Glen Echo, Maryland, near the Maryland shore, lies Sycamore Island. The island is reached by a human-powered rope ferry, not unlike ferries used for centuries along the Potomac. This 1977 photograph shows Ron King of Glen Echo powering the ferry across the 50-yard channel between the island and the Maryland shore. In the background is the Sycamore Island Clubhouse. The club was formed in 1885 and is limited to 155 families. (MLK.)

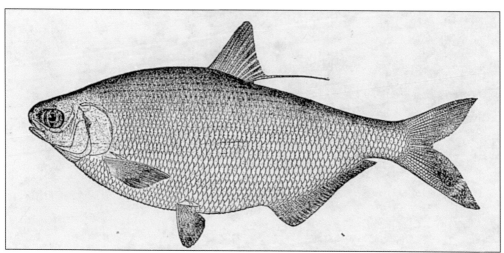

SHAD. The Gizzard shad (above) and Latrobe's sketch of an Alewife (below) represent the four species of fish in the Potomac. The numbers of these migratory fish of the tidal Potomac have been in decline since the early 19th century. This has been primarily through the rendering of their historic breeding grounds either unsuitable or inaccessible. An 1818 Washington newspaper advertisement described one such incident: "The south or shad birth, also adjoining the Fort [Warburton, now Washington] wharf, is from necessity discontinued and believed to be ruined by the envelopement [sic] of dug earth and other obstructions consequent to the Fort works." In 1999, such a traditional breeding ground was reopened to the shad when a fish passage was initiated through Little Falls dam. The Interstate Commission on the Potomac River Basin has been active in this shad restoration project since 1995. (MHS — II-39, J.)

ROCK GARDENS. The bucolic river between Stubblefield Falls and Little Falls is frequently described as an area of rock gardens and small islands. This picture of "Gay Nineties" water nymphs well illustrates this description. (MLK – 6045.).

SNAKE ISLAND AND LITTLE FALLS DAM. The foreground of this turn-of-the-century photograph shows the rapids called Little Falls, the dividing line between the Upper Potomac and the Tidal Potomac. In the background is Snake Island, the anchor for the Brookmont Dam at Little Falls, built in the 1950s to provide an intake pool, in addition to Great Falls, for drinking water for the Metropolitan area. This dam had a killer reputation annually causing one to multiple deaths by drowning. In 1986, the Army Corps of Engineers modified the dam to make it less dangerous. (MLK – 6048.)

Four

THE TIDAL POTOMAC
CHAIN BRIDGE TO ANACOSTIA RIVER

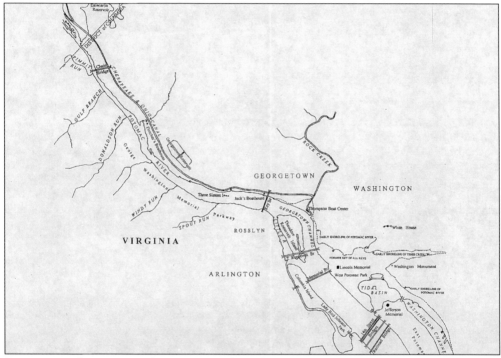

DISTRICT OF COLUMBIA. When D.C. was formed in 1791, it incorporated both shores of the Potomac. Sixty percent of the 10-mile square came from the state of Maryland and 40% from Virginia. Only in 1846 did the Virginia portion go back to Virginia by retrocession. The original western boundary is preserved in Arlington County's western border. The nation's capital was located at the head of navigation and was, in addition to being the seat of government, an active seaport. The shape of the eastern shore has changed dramatically from the dredging and filling activities of the Army Corps of Engineers. The dashed line represents the original shoreline. The Washington Channel was dredged and Potomac Park created with the spoil between 1882 and 1913. While many of the points have either changed names or disappeared over the years, Turkey Buzzard Point (so named because the currents deposited carcasses there, which attracted the vultures), between the Potomac and the Anacostia Rivers, is one of the oldest features of the coastline, serving as the site for a residential neighborhood, an arsenal, a penitentiary, and finally, for Fort McNair and the War College. (DH.)

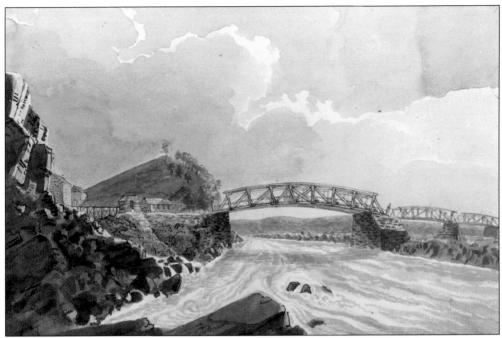

CHAIN BRIDGE. Benjamin Henry Latrobe painted this watercolor, which he entitled "Sketch of the Bridge at the Little Falls of the Potowmac. . .," in 1798, one year after its construction. This was the first bridge across the Potomac; it burned a few years later. The charges on this toll bridge were as follows: pedestrians 3¢; a horse and rider 8¢; two-wheeled vehicles 25¢; and four-wheeled vehicles 50¢. The engraving below depicts the third bridge in this location, a chain suspension bridge, which would give its name to all future bridges here, no matter their type. (MHS — III-23&MLK – 6010.)

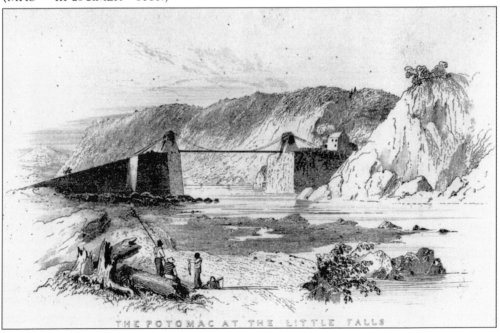

THE POTOMAC AT THE LITTLE FALLS

CHAIN BRIDGE. The wooden bridge being guarded in this engraving from *Frank Leslie's Illustrated Newspaper* for November 9, 1861, was built in 1855. It was the sixth bridge at this site and would last until 1874. While it was officially called the Little Falls Bridge, the people still called it the Chain Bridge. (MLK – 9336.)

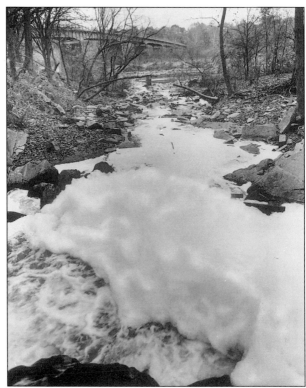

PIMMIT RUN, VIRGINIA. This photograph of detergent foam at the mouth of Pimmit Run appeared in the *Evening Star* for November 10, 1967. Such levels of pollution have been largely eliminated by federal and state legislation assisted by the actions of the Interstate Commission on the Potomac River Basin. (MLK.)

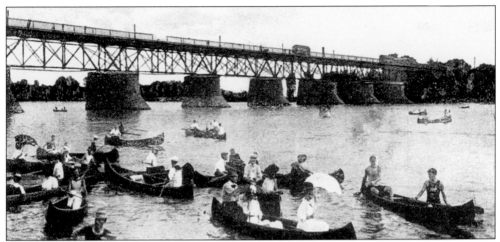

AQUEDUCT/KEY BRIDGE. Initially, the C&O Canal was to start near the head of tidewater on the Potomac, below Little Falls, about 5 miles above Georgetown and 12 miles above Alexandria. The citizens of Alexandria believed that they would have equal access to the canal commerce. When, in 1820, Washington merchants were able to get the plan changed so that the canal would reach the Washington Canal by way of Georgetown and Rock Creek, the Alexandrians were concerned that they would be cut out of the lucrative coal trade. Their apprehensions were justified, as shown by the relative commerce through the two ports. Prior to the canal Alexandria's export/import business consistently exceeded Georgtown's. As the canal moved westward, the commerce of Georgetown steadily increased until, as the canal reached Cumberland, it exceeded that of Alexandria. In 1830, Congress chartered the Alexandria Canal as an extension of the C&O. The greatest obstacle on this route was crossing the Potomac, which was accomplished by the construction of the Aqueduct Bridge completed in 1843. The first photograph, taken about 1910, shows the bridge in operation as a highway bridge. The 1962 *Star* photograph below shows the removal of the support piers from the bridge replaced by the Key Bridge in 1935. (Kip — 3964&MLK — 154,443.)

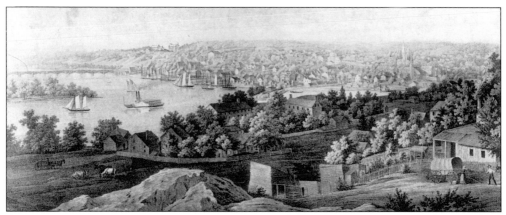

GEORGETOWN, DISTRICT OF COLUMBIA. Chartered by Maryland in 1751, Georgetown would remain a separate jurisdiction until 1871. This 1855 lithograph by E. Sachse & Co. of Baltimore depicts the city in 1830. It shows a thriving port at the eastern terminus of the Chesapeake and Ohio Canal. The functional Aqueduct Bridge is pictured in the background, over ten years before its time. (MLK – 3321.)

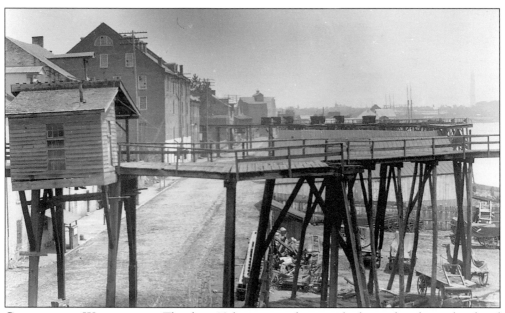

GEORGETOWN WATERFRONT. This late 19th-century photograph shows the elevated railroad that was used to load coal from the canal to the schooners. This coal/ice trade between Georgetown and Massachusetts represented Georgetown's mainstay. After the waterfront and canal were destroyed by a cataclysmic flood in 1889, Georgetown commerce never recovered. (HSW-Wagner 168.)

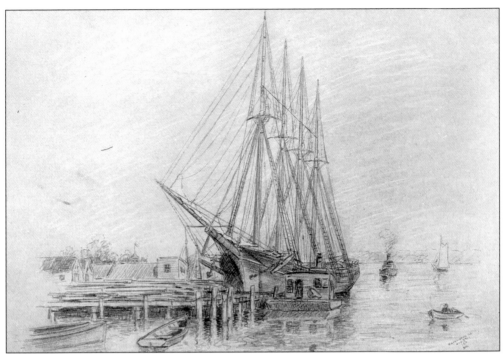

FOUR-MASTED SCHOONER. This pencil and pastel sketch was done by Winfield Scott Clime on August 7, 1913. The four-masted schooner was developed for the Georgetown coal and ice trade. She was over 300 feet long and could carry cargo weighing about 1,500 tons. One of its major advances was a donkey engine of 10 horsepower to assist in raising sail, hoisting anchor, pumping water, and loading and unloading cargo. This allowed the vessel to be crewed by a captain and five hands. (Kip – 1534.)

GEORGETOWN WATERFRONT, 1965. After the 1889 flood, the waterfront was reconstructed with under-financed, innovative, and less-desirable heavy industry. By the 1950s and 1960s, most of this industry was no longer functional. (MLK.)

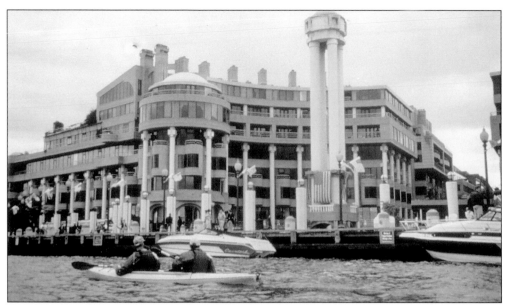

WATERFRONT GENTRIFICATION. This contemporary photograph of Harbor Place typifies the changes to the Georgetown waterfront. Several mills have been converted to condominiums and offices. The columns in front of the Harbor Place complex, topped with globular lights, are part of a flood protection system. At a flood warning, waterproof shields can be raised between these columns. (SS.)

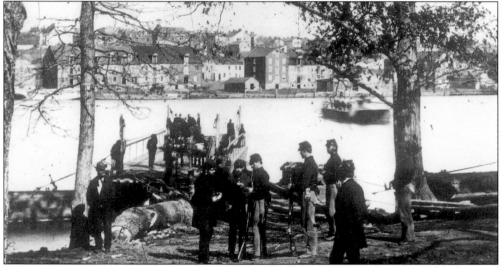

ROOSEVELT ISLAND FERRY. This Potomac Island, opposite Georgetown, has had many names over time. In 1681, Lord Baltimore first granted it as "My Lord's Island" to Capt. Randolf Brant in gratitude for his service as a scout and "Indian Fighter." Captain Brant promptly renamed the island "Barbados." It was also known as Analostan Island and, after being purchased by George Mason in 1717, as Mason's Island. Finally, the Roosevelt Memorial Association purchased Mason's Island in 1931 with money raised by popular subscription. Congress changed the name of the island officially to Theodore Roosevelt Memorial Island. This c. 1862 photograph by George N. Barnard shows the ferry between what was then known as Mason's Island and the Georgetown waterfront. (MLK – 3488.)

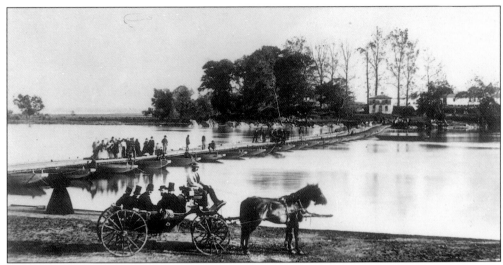

ROOSEVELT ISLAND BRIDGE. During the Civil War, a pontoon bridge was used between Virginia and Mason's Island. In addition to the plantation house, this 1865 photograph shows the barracks used by African-American troops during the war in the background. The photograph below shows the new crossing of the Potomac built in 1964 across Roosevelt Island. (MLK — 12,619, 154,467.)

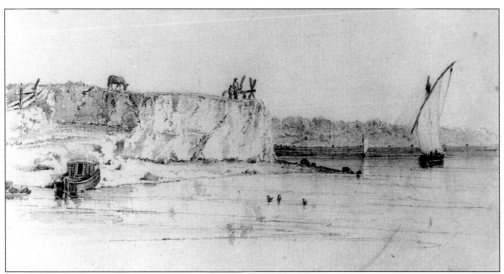

BRADDOCK'S ROCK. This 1851 drawing by Seth Eastman portrays the juncture of the Potomac with Tiber Creek. The area just beyond this point, called Braddock's Rock, was the industrial waterfront of the Foggy Bottom section of Washington. This port area disappeared in the Army Corps of Engineers dredging and filling operation that so dramatically changed the District's shoreline. The map at the head of this chapter shows this change. The lower photograph, probably taken before 1871, shows Braddock's Rock. The wall behind this rock is that of the Washington Canal, which was removed between 1871 and 1874. Braddock's Rock can now only be seen by peering down through a manhole cover on the approach to the Roosevelt Bridge. (MLK — 5882, MLK.)

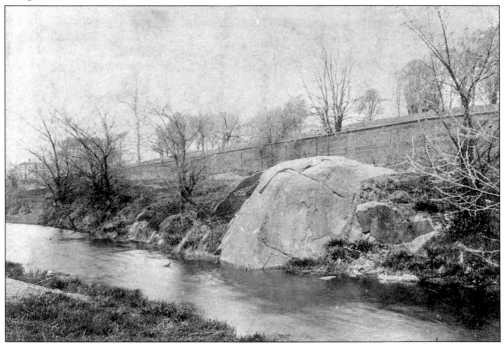

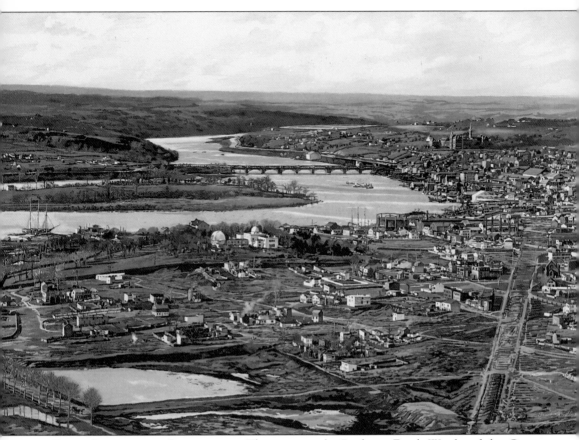

FOGGY BOTTOM AND GEORGETOWN. This painting by Professor Frank Wright of the George Washington University faculty of art is based on photographs taken from the platform at the top of the Washington Monument before the capstone was placed December 6, 1884. The old Naval Observatory is in the center of the picture with Foggy Bottom to the left, in the foreground. Virginia Avenue is under construction in the lower right, pointing to Rock Creek and Georgetown beyond. In the river is Roosevelt Island with the Virginia shore in the background. The bridge is the Aqueduct Bridge. (FW.)

WASHINGTON, DISTRICT OF COLUMBIA. This view of Washington from the Virginia shore shows the industrial cluster in Foggy Bottom, the bridge to Georgetown across Rock Creek, and an unfinished wing of the Capitol, c. 1800, the moment of the arrival of the government from Philadelphia. This engraving was made from a drawing by George Isham Parkyns. Below, an 1830 lithograph by E. Sachse & Co. of Baltimore depicts the city of 1830. Note the completed monument. Not only is this a later view enhanced by the artist's imagination; it is a perspective form the south rather than the west. It is labeled "View from the Lunatic Asylum" across the Anacostia River. (MLK -12582, 3300.)

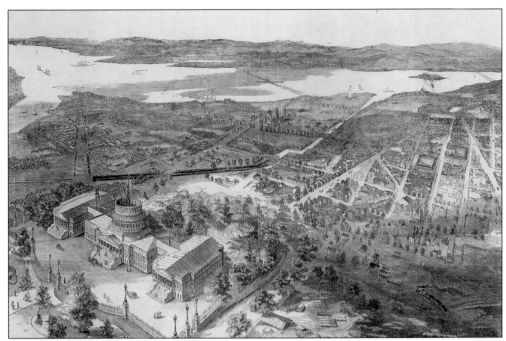

AERIAL RECONNAISSANCE. Thaddeus Sobieski Coullincourt Lowe convinced the Union high command of the value of a Balloon Corps for observation in the spring of 1861. He could even direct artillery fire from the balloon by means of a telegraph key in the balloon, which was connected by wire to the ground. Professor Lowe took correspondents of the major weeklies aloft in his balloon and this engraving from *Harper's Weekly* for July 27, 1861, is the result of one such ascension. (FtWd.)

THE WATERGATE. This contemporary photograph of rising tiers of steps from the river, across Rock Creek Parkway to Riverside Drive at the level of the Lincoln Memorial, were part of the 1924 plan for the Arlington Memorial Bridge. The design of this area by the firm of McKim, Mead, & White included the magnificent steps as a ceremonial entrance to monumental Washington from the water. During the 1999 refurbishing of the Washington Monument, the monument was covered by a decorative safety screen, which was illuminated at night. (FG.)

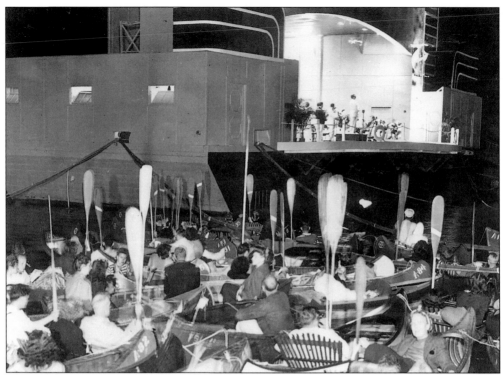

WATERGATE CONCERTS AND MEMORIAL BRIDGE. One of the most popular uses of the ceremonial steps was the Watergate Concerts. In the summer of 1935, the National Symphony Orchestra played concerts twice a week from a barge anchored in the river at the base of the steps. The concerts were discontinued during World War II and, while re-initiated at the end of the war, were permanently discontinued because of the increasing noise of takeoffs and landings at the then new national airport. These concerts were extremely popular with boaters who could listen from the water. In this 1946 photograph, boaters are raising their paddles during the national anthem. The 1959 photograph below shows the barge being removed to the Navy Yard through the Arlington Memorial Bridge. Generally conceded to be the Potomac's most beautiful bridge, construction began on the plan of McKim, Mead, & White in 1926. The bridge was dedicated on January 16, 1932. (MLK — 154,448, 154,444.)

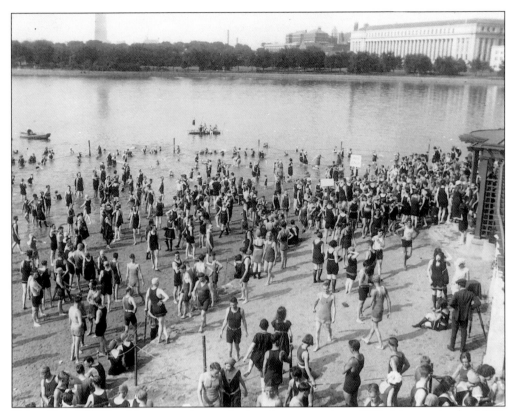

TIDAL BASIN BEACH. No picture better depicts the segregation of Washington in the 1920s than does this picture of the all-white bathing beach at the Tidal Basin. The federally funded beach opened in 1918, during the Woodrow Wilson administration. Public concern for tide-born debris and the lack of beach access for African Americans led to the beach being closed in 1925. (MLK – 968.)

LONG BRIDGE. The first bridge from the City of Washington to Virginia was the Long Bridge built in 1808 by a private subscription company. This 1861 photograph shows the bridge under guard. (MLK – 4488.)

FOURTEENTH STREET BRIDGE COMPLEX. During the 1898 construction of a new railroad bridge across the Potomac at the level of 14th Street, the young engineer in charge, John Meigs, shot this picture of the workmen constructing a pier. The 1949 photograph below shows the construction of a new highway bridge from the Virginia perspective. Today, five bridges cross the Potomac as part of this complex, including a metrorail bridge and John Meigs's 1898 railroad bridge. (HSW — M-42, MLK – 1538.)

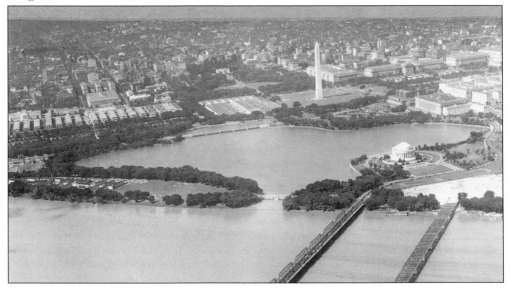

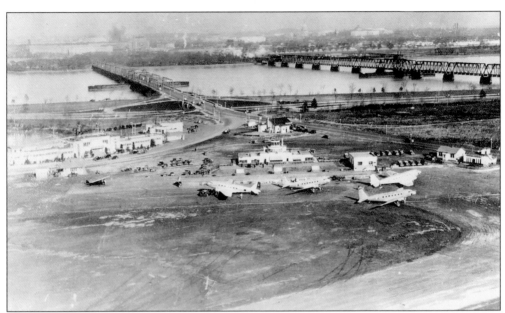

HOOVER AIRPORT. At its inception in the late 1920s, near the Virginia end of the 14th Street Bridge, Hoover Airport did not meet minimal national standards. It was too small and was crossed by a highway where access was controlled by traffic lights. Congress ignored local pleas for a new airport until the immediacy of the Second World War caused Franklin Delano Roosevelt to request a new airport to meet national defense needs. This 1939 photograph shows the relationship to the bridge and to the city. (MLK – 4026.)

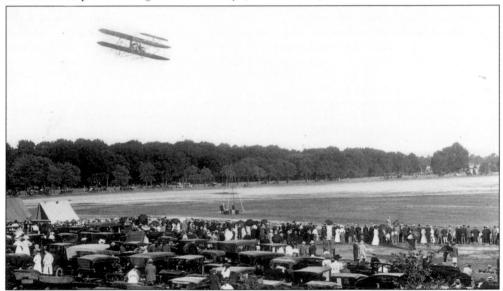

WRIGHT FLIGHT, 1908. After Prof. Samuel P. Langley's disaster with his *Aerodrome* at Widewater, Virginia, in 1903, (see page 118) the U.S. Army was reluctant to invest any more money in flying machines. Pres. Theodore Roosevelt saw the potential for aviation and initiated the procedure that led to Orville Wright's demonstration flights from Fort Myer, Virginia. These flights became a great attraction for Washingtonians, as illustrated in this September 1908 photograph. (MLK – 430.)

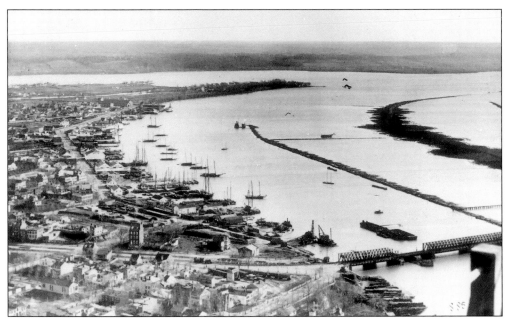

WASHINGTON CHANNEL AND POTOMAC PARK. A potpourri of natural and man-initiated factors combined to make the Washington Channel the premier port on the Potomac. The activity of the Army Corps of Engineers in deepening the channel, then their changing the shoreline by their deposition of spoil from the dredging wiped out the port at Foggy Bottom. The great flood of 1889 destroyed the port of Georgetown, while the Baltimore and Ohio Railroad's reluctance to restore their Chesapeake and Ohio Canal shifted the coal trade to the Washington Channel. The 1880s photograph above shows an early stage of the work, while the 1892 photograph below shows the virtually completed Potomac Park land mass. (MLK — 4487, 9260.)

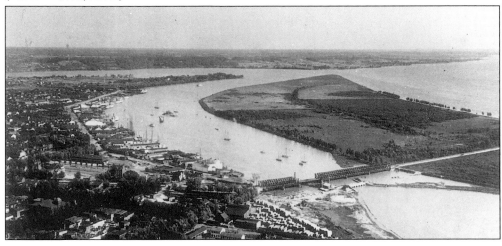

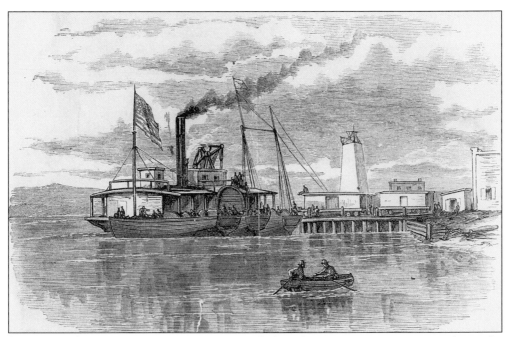

SIXTH AND SEVENTH STREET WHARFS. Even before the improvements were made to the Washington Channel, the City of Washington had major port activity at the Sixth and Seventh Street Wharfs. J.B. Geyer's antebellum sketch of the Washington to Alexandria Ferry depicts the Seventh Street Wharf. The 1863 lithograph depicts the bustle of activity during the Civil War at the Quartermaster's main supply point for the Army of the Potomac on the Sixth Street Wharf. (MLK — 3489, 14506.)

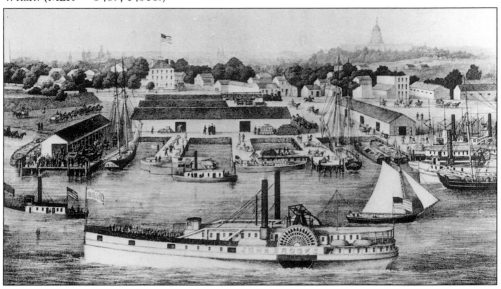

CITY OF WASHINGTON. This double-ended side wheeler was built in 1868 for the Alexandria & Washington Steamboat Company. Together with her sister ship, the *City of Alexandria*, she carried passengers and freight between the two cities. The last of the ferries held on into the 1930s. Today, there is again talk of a revival of the service. (MLK – 4027.)

FLOOD, 1889. The great flood of 1889 inundated the city to above Pennsylvania Avenue. It is therefore not surprising that the wharfs were under water. (MLK – 154464.)

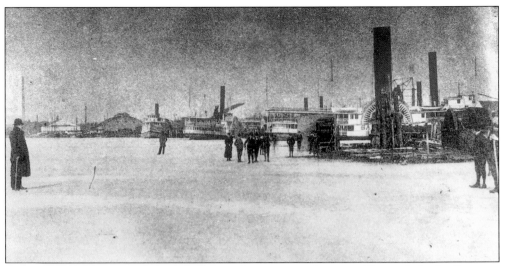

FREEZE, 1887. This view of the wharfs from the river is indicative of how solidly the Potomac freezes in cold winters. (MLK – 7873.)

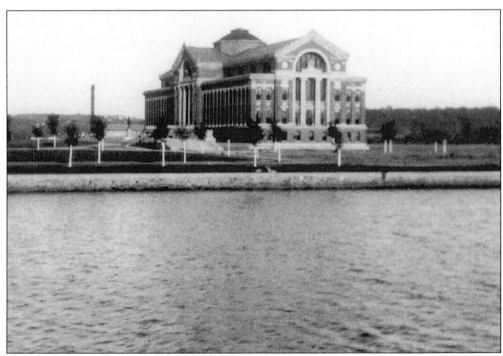

ARMY WAR COLLEGE. Turkey Buzzard Point has been the site of many governmental activities over the years. Here, the U.S. built its Washington arsenal in 1803; Congress located the national penitentiary here in 1826; the Lincoln assassination conspirators were tried and hanged here; and the lovely McKim, Mead, & White Army War College was located here, as shown in this 1908 photograph. (MLK – 2978.)

THE TIDAL POTOMAC
ROACHES RUN TO JONES POINT

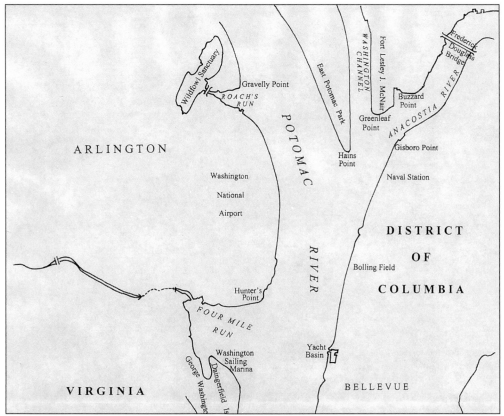

ALEXANDRIA. This southwestern portion of the original District of Columbia features primarily Alexandria, Virginia. While the river is all in the District, the land above means high tide on the western shore is in Virginia. The 1791 District included the much older towns of Alexandria (1749) and Georgetown (1751). Ironically, the first border marker of the District of Columbia (the southernmost tip of the -mile square) is located on Jones Point at the southern boundary of Alexandria. It is from this point that the boundaries of the District were surveyed. Most of the land for the national airport was made from the dredging activities of the Corps of Engineers in the Potomac. (DH.)

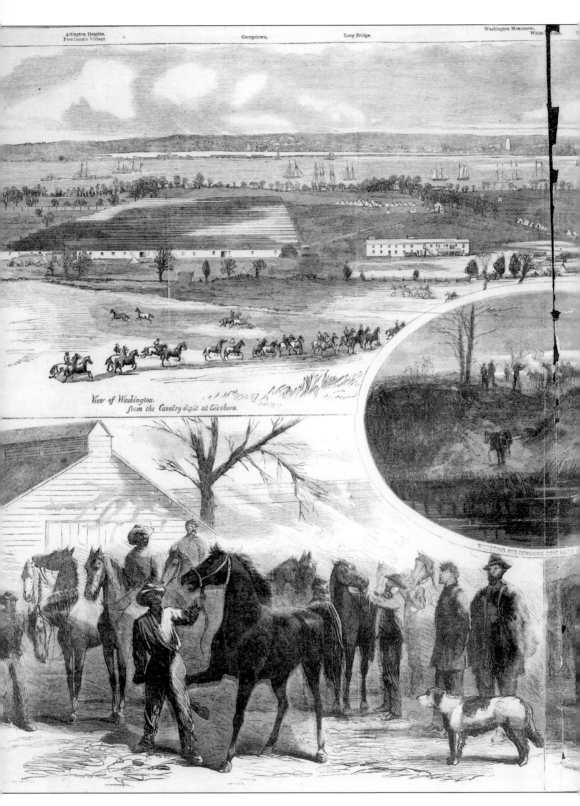

View of Washington.
from the Cavalry depot at Giesboro.

SHOOTING AND REMOVING CONDEMNED

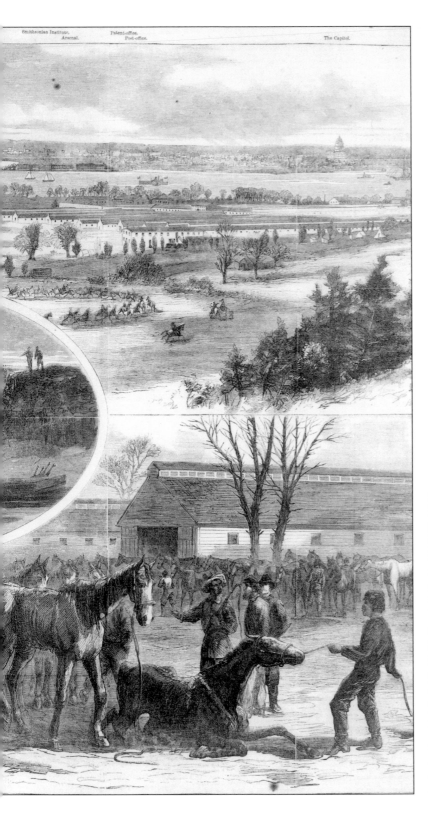

Smithsonian Institute.
Arsenal.
Patent-office.
Post-office.
The Capitol.

GIESBORO POINT. During the Civil War, the Quartermaster General maintained a cavalry depot at Giesboro Point. This unique view of Washington from that vantage point to the south appeared in *Harper's Weekly* on June 15, 1865. Most of the major buildings of the city are labeled at the top of the engraving. (HSW — Machen 536.)

83

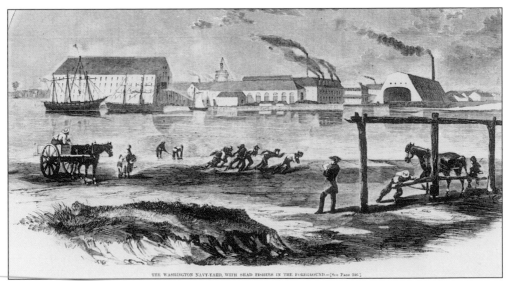

THE WASHINGTON NAVY-YARD, WITH SHAD FISHERS IN THE FOREGROUND.—[See Page 296.]

THE NAVY YARD. On February 25, 1799, Congress appropriated $1,000,000 to build "six ships of war," part of this money was to purchase land for six navy yards. One of these was in the new federal city. This 1861 engraving shows the Navy Yard on the west bank of the Anacostia River in the background, with a depiction of commercial shad fishing techniques in the foreground. (FtWd.)

WILLOW OAK. The Willow Oak has been alleged to be Thomas Jefferson's favorite tree. If so, our third president chose well. It is a beautiful native tree that is now used extensively in the nation's capital as a street-tree. It gets its name from its long, narrow, willow-like leaves. (L.)

ROACHES RUN. This engraving from the *Illustrated London News* of April 12, 1850, illustrates a different ethic toward animals than the 1965 photograph below of waterbirds in the Roaches Run Waterfowl Sanctuary. Here, with all of the noise from the neighboring National Airport, it is possible to observe a wide variety of ducks and other waterbirds. From the market hunters of the 19th century to the preservationists of the 21st century, the river has provided amply. (MLK — 6047, 6052.)

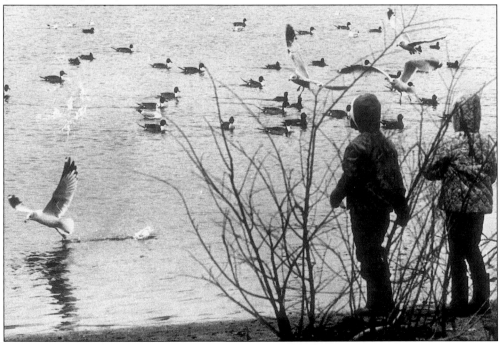

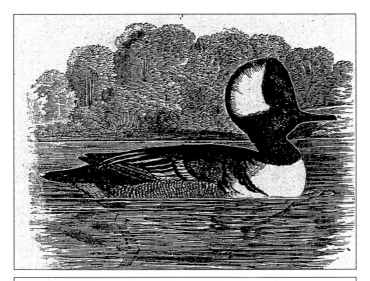

DUCKS. Roaches Run provides excellent winter viewing for many species of ducks. Fish ducks, like the Hooded Merganser, have long, thin, narrow bills with serrated edges to better hold fish. Sea ducks, like the Bufflehead, are short-necked, compact birds that dive for their food and migrate from their breeding grounds in the far north. Diving ducks, like the Canvasback, are so heavy bodied that they require a running start on the water in order to take off. (K.)

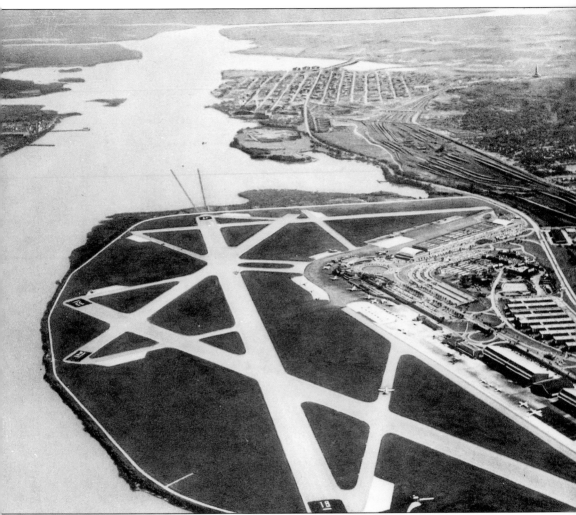

NATIONAL AIRPORT. This 1941 aerial view shows the relationship of this busy airport to the Potomac River and to Alexandria, Virginia, in the upper center. Dedicated in September 1940, the airport occupies 750 acres, built on 20 million cubic yards of fill land, south of Gravelly Point and the mouth of Roaches Run. The site was selected in 1938 by Franklin Delano Roosevelt for a new Washington airport. When opened, it was hailed by *Aero Digest* as "the first among *all* airports in the extensiveness of its ultra modern equipment and facilities." (MLK – 27.)

GEORGE WASHINGTON MASONIC NATIONAL MEMORIAL. George Washington was the first worshipful master of the Alexandria Masonic Lodge at its organization in 1788. The Masons of Alexandria honored him with this memorial containing artifacts and stained-glass windows depicting scenes from his life. (GWM.)

ALEXANDRIA, VIRGINIA, WATERFRONT. This 1903 picture of commercial buildings at the water end of King Street in Alexandria captures the flavor of the old port town. Today, this area has been completely gentrified. (HSW — Rambler-1903.)

BEAVER. In 1631, Capt. Henry Fleet anchored two leagues short of the great falls on the Potomac, where he obtained "800 weight" of Beaver pelts at Natcochtanke and attempted to travel up river by canoe in order to obtain more pelts. In 1692, Cadwalder Jones, a Beaver trader, built a cabin at what would become known as Jones Point. From these early indications of the abundance of Beaver in the metropolitan Washington area, Beaver numbers declined to near extinction. Today, they thrive to the point of nuisance throughout the basin. (DNR.)

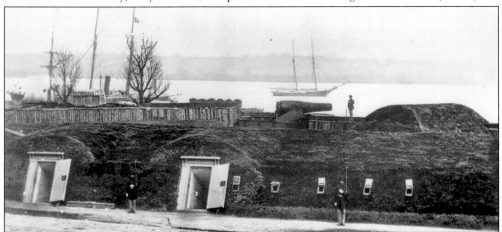

BATTERY RODGERS. The location of this battery is preserved in the name Battery Cove on the southern boundary of Alexandria, at the base of the Wilson Bridge; however, no remains of this fortification remain. Built in 1863, after the crises of Confederate naval action on the Potomac had passed, this fort never saw action. Rodgers was armed with five 200-pound Parrott rifles and one 15-inch Rodman gun, which can be seen on the top of the rampart. This contemporary photograph illustrates the airing of the powder magazines. (FtWd.)

WILSON BRIDGE. Wilson Bridge is the last bridge in the metropolitan area. It is located on the Capital Beltway surrounding Washington; when this drawbridge is opened for ship traffic, automobile traffic is seriously disrupted. This 1961 bridge is 5,597 feet long and 89 feet wide. Its condition has deteriorated to the point that replacement is necessary, and this has led to serious debate by citizens of the three jurisdictions through which it runs. (AKCo.)

JONES POINT PARK. This point was named for Cadwalder Jones, a British trader who established a trading post here in 1682. It is the southern zero point for the survey of the "ten mile square" of the District of Columbia. Here, Maj. Andrew Ellicott and Benjamin Bannecker set the first boundary stone marking the federal district in 1791. This lighthouse, possibly the first inland lighthouse in the United States, was built between 1855 and 1856. It was in active operation from 1856 to 1919. This photograph of the lighthouse at the Jones Point was taken during 1940s. (HSW – 27.)

Six

THE TIDAL POTOMAC
OXEN COVE TO POINT LOOKOUT,
THE MARYLAND SHORE

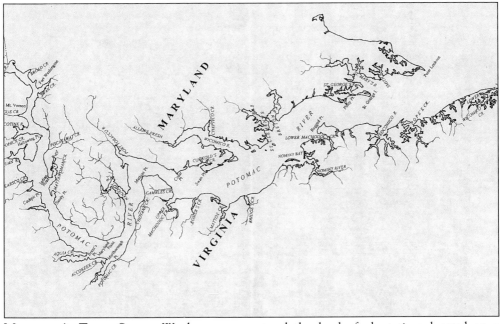

MARYLAND'S TIDAL SHORE. We have now entered the land of plantations located on a tidal river, each with its own wharf and thus a direct link to Europe. The original European colonization of Maryland took place at the mouth of the Potomac River. In 1634, two small ships, *Ark* (72 feet long) and *Dove* (42 feet long), carried about 300 English colonists to the new colony of *Terra Maria* (the charter was in Latin), named for Henrietta Maria—the queen of Charles I. They first landed on St. Clements Island on Ladie's Day, March 25th. To honor this event, the colonists named their first capital Saint Maries for the Blessed Virgin Mary. This Catholic influence is reflected in many of the place names in southern Maryland. Since the Potomac represented the principal access to Washington, both the Union and the Confederacy attempted to control its waters. During the first year of the Civil War, 1861-62, the Confederate States blockaded the river by means of forts located on the Virginia shore. The United States built answering fortifications on the Maryland shore. After March of 1862, the Union firmly controlled the river. (DH.)

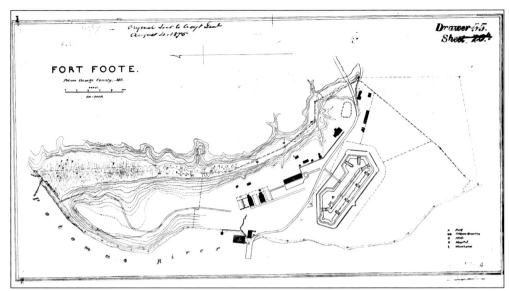

FORT FOOTE, MARYLAND. The three main positions defending Washington from the water during the Civil War were Battery Rodgers, Fort Foote, and Fort Washington. Fort Foote was built between 1863 and 1865 and remained in active service until 1878. The post-Civil War drawing above shows the relationship of the fort to the river. The fort is preserved and maintained by the National Park Service. (FtWd.)

WANT WATER, MARYLAND. Broad Creek is worth a side trip into this interesting historic area. Want Water at the head of Broad Creek in Prince George's County, Maryland, is the oldest extant house in the Washington Metropolitan Area. This house on the water's edge was probably built in the first decade of the 18th century by Col. Thomas Adison as part of the development of the State Assembly mandated port of Aire. This drawing was made in 1935 as part of the Historic American Buildings Survey. Today, only the two stone end-walls and chimneys remain. On the top of the hill overlooking Want Water is the more typical brick Georgian mansion, Harmony Hall, built in mid-18th century by James Marshall. Just up Henson Creek stands St. John's church, built in 1722. (HABS.)

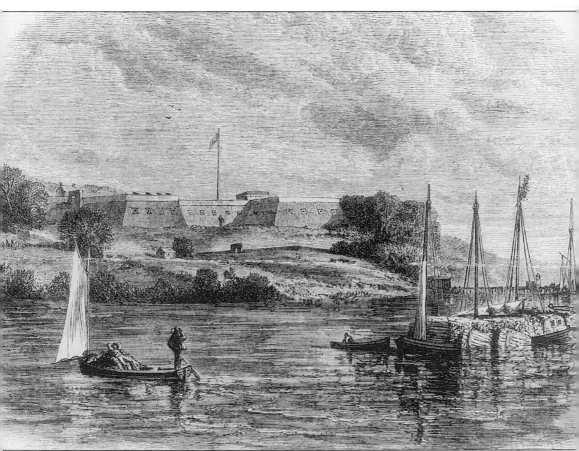

FORT WASHINGTON, MARYLAND. This 1874 illustration from *Picturesque America* represents the romantic, post-Civil War view of this fort. The site for Fort Washington, across from Mount Vernon, was chosen by George Washington in 1795 to protect the national capital from a water attack. It was of no help in the War of 1812 since its commander blew it up in anticipation of the arrival of the British. The present fort was completed in 1824. (MLK — 3756&MHS — B1970.)

BRYAN POINT WHARF. This popular fishing pier is located at the National Colonial Farm in Piscataway National Park. Byron Williams, the first president of the Potomac Water Trail Association is in the foreground, in his kayak. (AKCo.)

FARMINGTON WHARF. This 1956 photograph of one of the last commercial wharfs on Piscataway Creek preserves an early tradition of the Potomac that lasted from the early 17th-century to the mid-20th century. (MHS.)

BARN SWALLOW. This ubiquitous bird of summer may be found throughout the basin. One of its favorite nesting sites is the underside of wharves. This places them near their mosquito prey. While the adults are easily identified by their deeply forked tails, the young start out with a very shallow fork. (R.)

ACCOKEEK CREEK MOUTH. Marshes like this are common in the mouths of tributaries of the tidal Potomac. The kayak is ideal for exploration at water level. (AKCo.)

NORTHWEST ELEVATION

FEET 1/4"=1'-0"
METERS 1:48

FIELD MEASUREMENTS BY
DENVER SERVICE CENTER, FALLS CHURCH
DRAWN BY: PAUL D. DOLINSKY, INKED BY REBECCA TRUMBULL, 1983

| NATIONAL ARCHITECTURAL AND ENGINEERING RECORD NATIONAL PARK SERVICE UNITED STATES DEPARTMENT OF THE INTERIOR | STATE ROUTE 227 AT POTOMAC RIVER | NAME AND LOCATION OF STRUCTURE MARSHALL HALL BRYANS ROAD VICINITY CHARLES COUNTY MARYLAND | SURVEY NO. MD 891 | HISTORIC AMERICAN BUILDINGS SURVEY SHEET 5 OF 6 SHEETS | |

MARSHALL HALL, MARYLAND. The western portion (to the right) of this modest Georgian house was built *c.* 1725 by Thomas Marshall on land acquired by the family in 1650. He added the eastern section *c.* 1760. The Marshall family retained the plantation until 1866. The house and grounds were acquired by the National Park Service in 1974. In 1981, the house burned and the remaining brick walls were stabilized by the Park Service. (HABS.)

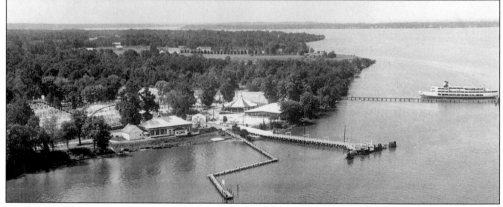

MARSHALL HALL: THE AMUSEMENT PARK. Before the turn of the 20th century, the plantation was developed as an amusement park. It was one of the great attractions for tourists from Washington and was frequently combined with a trip to Mount Vernon on the Virginia shore. This undated aerial photograph gives an idea of the extent of the park. (MLK.)

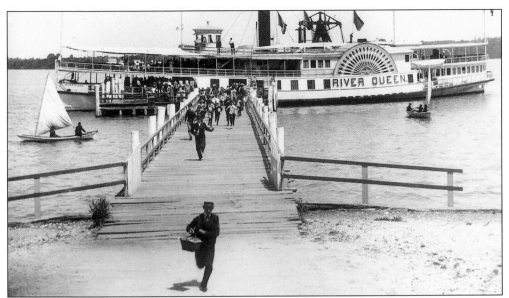

THE RIVER QUEEN. The *River Queen* was built in 1864 and was brought to the Potomac to carry President Lincoln to his meeting with Lt. Gen. U.S. Grant at City Point, Virginia, in February of 1865. After the war, the ship became a fixture in the Potomac tour circuit until it burned in 1911. Here, it is discharging passengers at Marshall Hall Amusement Park. (MLK – 1407.)

INDIAN HEAD, MARYLAND. The evolution of this name can be traced in old charts. In 1710, it is shown as "Pamunkey Indian Lands;" in 1776, it was called "Indian Point," in 1835, "Indian Head Lands," and finally, in 1866, "Indian Head." The Naval Station at Indian Head was established in 1890. Ensign Dashiele located this site as a proving ground for the testing of guns, munitions, and armour plate. This turn-of-the-century picture illustrates the base's mission as well as a more casual attitude toward civilians than that held by today's military. (MLK – 6006.)

MATTAWOMAN CREEK, MARYLAND. The supply depot at Rum Point, Mattawoman Creek, was the position of supply for the Union encampments and batteries in the area of the Maryland Bend. This 19th-century engraving illustrates some of the activity at that terminal. Today, Mattawoman Creek lends itself to more tranquil pursuits. This is the site of General Smallwood State Park, where each October, the Charles County Office of Tourism and the Charles County Commissioners sponsor one of the country's leading Bass tournaments. The picture below shows a couple of unidentified participants with their catch. (FtWd&CC.)

U.S.S. GEORGE WASHINGTON PARKE CUSTIS. Professor Lowe of the Balloon Corps even made his balloons more mobile by inventing the aircraft carrier pictured to the right. He took an old river steamer and removed its superstructure to create a platform for the launch of balloons. By the middle of 1863, the army had inexplicably abandoned the Balloon Corps. This painting of the *G.W.P. Custis* is in the Lowe Collection at the U.S. Naval Historical Center. (NH – 2079.)

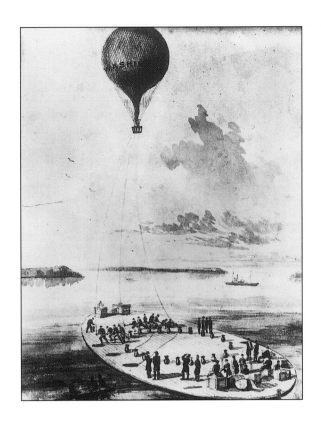

Stump Neck. Mouth of Chickamoxen Creek. Mrs. Budd's house.

THE BATTERIES ON THE POTOMAC—BUDD'S FERRY.—SKETCHED BY AN OFFICER IN THE POTOMAC FLOTILLA.—[SEE PAGE 751.]

BUDDS FERRY. The first ferry at this site was in 1757 and ran from Roger Chamberlaynes place on Goose Bay, Maryland, to the mouth of Quantico Creek, Virginia. A widow Budd operated this profitable ferry throughout the Civil War. As Union General Hooker's headquarters, this was one of the nation's key positions in southern Maryland. Artillery were mounted here to oppose the Confederate batteries of the Quantico complex. In addition, this was the lower Potomac station of the Balloon Corps. (FtWd.)

LONG NOSE GAR. Paddlers will find amusement in June watching these prehistoric fish go through their mating rituals in the shallow waters of marshes. These watercolors by B.H. Latrobe are in enough detail to easily identify this fish to species. (MHS — II-41.)

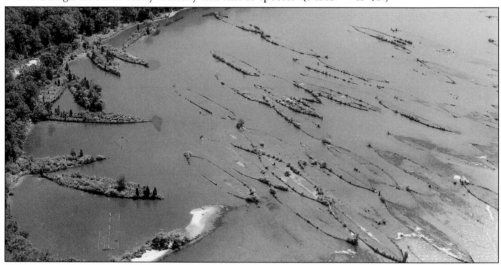

THE GHOST FLEET OF MALLOWS BAY, MARYLAND. On 1841 charts, this creek mouth was labeled Marlows Creek. The name change occurred rather recently when, in 1930, there was a particularly good year for Swamp Rose Mallow and locals began calling the creek mouth Mallows Bay. Between 1924 and 1944, over 100 World War I-era surplus, wooden cargo ships were towed to the mouth of Marlows Creek from Brent Marsh, Wide Water, Virginia. Here, they were salvaged for metal parts and, in the process, burned and sunk. Native vegetation has colonized the hulks, creating islands of vegetation. Donald Schomette, one of the area's leading marine historian/archaeologists, has studied this complexity and leads in the efforts to protect this unique assemblage. (DS.)

GREAT BLUE HERON. At once, one of the most spectacular and common birds seen along the shallows of the Potomac, the great blue heron breeds on one of the tidal river's tributaries. With over 2,000 birds, the Nanjemoy heronry is one of the Atlantic Coast's largest. This heron represents a group of birds that have survived nearly unchanged for at least 14 million years. One reason for their success has been their varied diet. Like most of their kin, they eat primarily fish and crustaceans, but when the need arises, they have been known to eat sora rails, muskrats, gophers, and norway rats. (RP.)

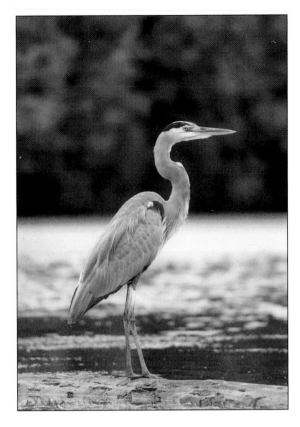

U.S.S. PAWNEE. She was the largest ship of the Potomac flotilla, a regular sloop of war; she was armed with eight 9-inch guns and two 12-pounders and, thus, could deal with anything the Confederates could put against her on the Potomac. Much of her time was spent, as shown in this engraving, inspecting civilian craft for contraband. (FtWd.)

KINGS CREEK, MARYLAND. Kings Creek enters Nanjemoy Creek just before Balls Point on the east side. Here, Col. John H. Hughes had hidden a large rowboat to be used in the plot to kidnap Abraham Lincoln. Hughes sheltered and fed assassin John Wilkes Booth in his flight after killing President Lincoln. It was from here that Booth and David A. Herold finally crossed the Potomac to Gumbo Creek, Virginia. (FG.)

BLOSSOM POINT, MARYLAND. Shown in this contemporary photograph is Blossom Point—a 30-foot eroding embankment. The left side of this photograph is the original site of Ballast House. This house was built about 1800 by the Jesuits. The house was built of brick, probably of local origin, not ship's ballast as the name implies. In 1979, as part of the Historic American Building Survey, the house was photographed, measured, and its condition evaluated. As a result, the army agreed to stabilize the house and move it about one mile. Instead, the army offered the house for sale to anyone who would undertake the move. When there were no takers, they disassembled the house with state approval. (FG.)

DENTS MEADOW, PORT TOBACCO, MARYLAND. After John Wilkes Booth shot Abraham Lincoln on April 14, 1865, Booth escaped to Charles County, Maryland, a hotbed of Confederate sympathy. There, he contacted Thomas A. Jones, the clandestine chief mail agent for the Confederate "Secret Line" in Charles County. Jones hid Booth and his companion David A. Herold in Dents Meadow, where a boat was hidden. The 1897 photograph above is the hiding place, as pointed out by Jones to an assassination investigation. The contemporary photograph below is a view of Dents meadow from the water. When Booth and Herold attempted to cross the Potomac into Virginia, they became confused and ended up at the mouth of Kings Creek, a tributary of Nanjemoy Creek. (MSA — SC1897-09-010&FG.)

OYSTER. These tasty bivalves have made a comeback in the lower Potomac. Over harvesting, periodically low salinity, and disease have greatly reduced the oyster population of the Potomac. Good conservation practices and replanting programs have brought the oysters back to many bars in the river and its southern tributaries. (DNR.)

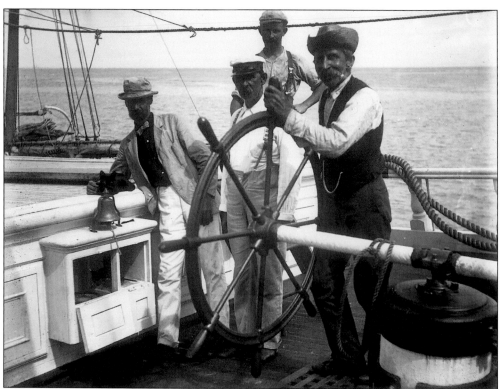

WATERMEN. John Meigs took this photograph of watermen at work on the lower Potomac, about 1896. At the time of this picture, the trade of waterman was thriving; fin fish and shell fish catches were astronomical and the market was growing through improved transportation. Today, there are very few full-time watermen left and most of them doubt if the next generation can follow the trade. (HSW — M-27.)

BLUE CRAB. Their scientific name means "Beautiful Swimmers;" certainly to both those who draw their income and to those who draw their nourishment from the Potomac, these crabs live up to their name. The Blue Crab population numbers cycle in both the river and the bay and it is not always easy to sort out population decline from a normal low in the cycle. When the 1999 harvest (May through July) on the Potomac declined to 26,000 bushels, less than half of the average 56,000 bushels, the Potomac River Fisheries Commission established new, more restrictive regulations on the harvest. (DNR.)

ST. MARYS CITY, MARYLAND. This 1934 photograph of St. Marys City is near the site of Maryland's first capital. On March 27, 1634, the *Ark* and *Dove* landed over 100 English settlers here to form the first permanent European community in Maryland. The wharf pictured above is a reminder of St. Marys City's focus on the water. (MHS.)

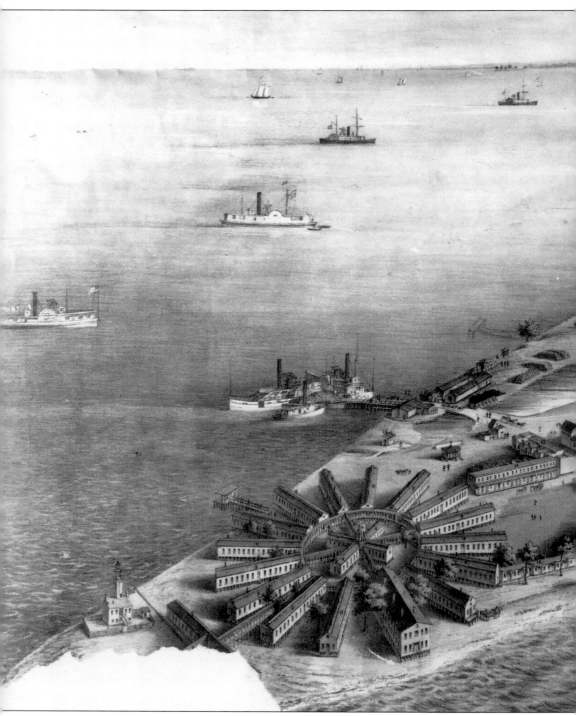

POINT LOOKOUT, MARYLAND — THEN. This lithograph is from the records of the Office of the Quartermaster General at the National Archives. The plain line drawing does not tell the story adequately of the suffering and death that went on in this, one of the Union's most notorious

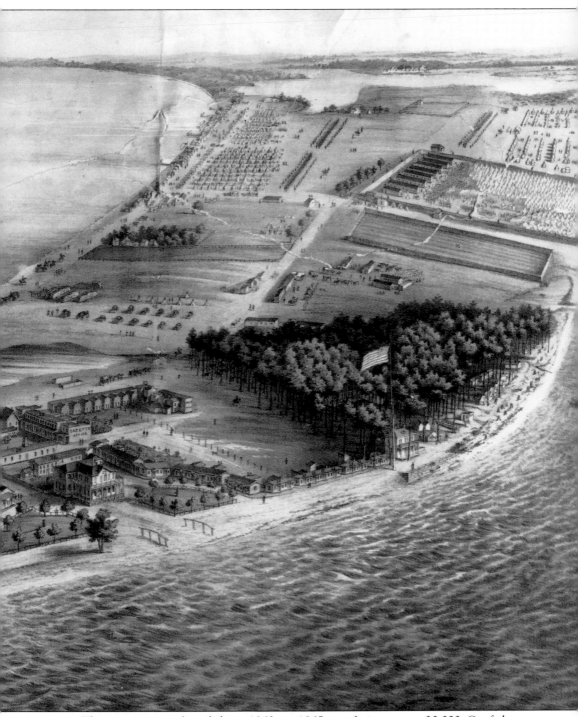

prisons. The prison camp lasted from 1863 to 1865, confining up to 20,000 Confederate prisoners. More than 3,500 deaths occurred in this camp. (NARA.)

LOBLOLLY PINE. As we proceed down the Potomac, the hardwood forest gradually changes, with pines replacing hardwood species, until the Chesapeake Bay when the forest is almost pure Loblolly Pine. This tree is distributed along the Atlantic Coast and commonly found in old fields and barren and sandy tracts. This is the common Yellow Pine of the lumber market. (Trees.)

POINT LOOKOUT, MARYLAND — TODAY. This area that has been a prison camp, a hospital, and a resort is now a Maryland State Park. The variety of habitats, from a Loblolly Pine forest to salt marshes, suits a variety of activities. There are ramp sites, where kayaks or canoes can be launched, or beautiful beaches, like the one above, for just relaxing. The center of the point is occupied by Lake Conoy, where you can quietly seine for interesting marine critters. (AKCo.)

Seven

THE TIDAL POTOMAC
GREAT HUNTING CREEK TO SMITH POINT,
THE VIRGINIA SHORE

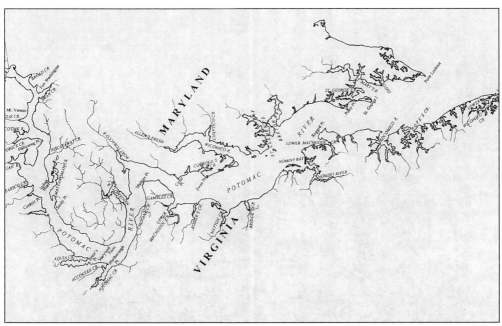

VIRGINIA'S NORTHERN NECK. All of this land between the Potomac and the Rappahannock Rivers was part of the huge land grant of Lord Fairfax (see the description of the Fairfax Stone on page 10). European settlement occurred in the middle of the 17th century, proceeding from the tip of the peninsula to its base and from the shorelines to the interior. Family names like Lee, Washington, Tayloe, Mason, Pope, Ball, and Fairfax all add luster to this coast. Because of the river being in Maryland, many resort areas on the Virginia shore were able to offer gambling when it was illegal in Virginia, but legal in Maryland, by locating the casino on piers over the water. Several very large military installations dominate the upper end of this area. (DH.)

SWAMP-HONEYSUCKLE. This six-foot shrub bears one-and-one-half inch, white or pink-tinged flowers with sticky, tubular bases, and long projecting filaments in clusters at the ends of branches. The flowers are very fragrant and attract bees, butterflies, and moths when they appear in June and July. (D.)

DIAMONDBACK TERRAPIN. This aquatic turtle, the mascot of the University of Maryland, inhabits brackish water marshes along the lower Potomac and its tributaries. As in many sea turtles, sex in the Diamondback Terrapin is determined by the temperature of the nesting sand where the turtle hatches. Warm sand produces females; cooler sand produces males. Nesting season is in the summer months of May, June, and July. (DNR.)

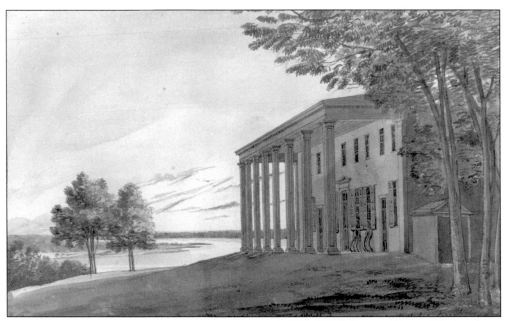

MOUNT VERNON. The earliest rendering we have of Mount Vernon is the watercolor above painted by Benjamin Henry Latrobe on July 16, 1796. More typical is this 19th-century engraving by A. Dick (below) with the U.S. Frigate *Potomac* in the background. (MHS — II-11&HSW — Machen 346.)

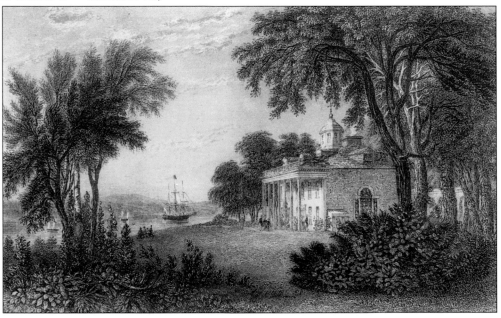

SASSAFRAS. This small tree with its mitten-shaped leaves can be found all along the Potomac. Its bark and roots yield aromatic oil that is used in soap. The roots are used to make Sassafras tea. (L.)

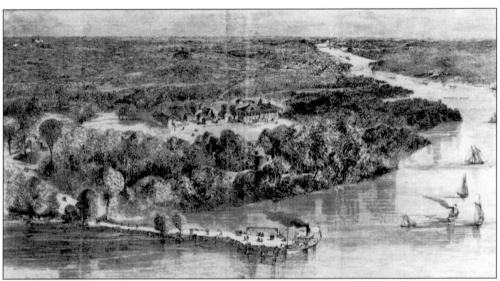

TOURIST MECCA. By the 1870s, Mount Vernon had become the destination of many tourists to Washington. The trip was made by river steamer to the home of George Washington where the tourists picnicked on the grounds. Such a trip is brilliantly described by Henry Adams in his novel *Democracy: An American Novel.* (MLK — 154,465.)

BALD EAGLE. When America adopted the Bald Eagle as its national symbol in 1782, there were as many as 100,000 birds nesting in the area that would become the lower 48 states. In 1963, there were only 417 pairs left in the same area. With the banning of the use of DDT in 1972 and the comprehensive listing of the Bald Eagle on the Endangered Species List in 1978, this bird has made a remarkable recovery. In 1998, there were 5,748 breeding pairs in the contiguous United States. Maryland and Virginia combined had 103 pairs in 1982; by 1998, they had 492 pairs. This success story resulted in President Clinton proposing on September 7, 1999, that this species be taken off the Endangered Species List. (C.)

MASON NECK, VIRGINIA. This peninsula, between Gunston Cove and Occoquan Bay, has a high percentage of its land in public ownership. The many habitats include some of the area's largest fresh water marshes. The great marshes serve as the winter home to well over 250 Bald Eagles. The marshes represent many wonderful opportunities for exploration. (AKCo.)

Rec:
Five Yds of green Baize
& d° of List of Broad Cloth
Divide into two portions,—
apply the same to the Part likely
to be affected from 4 in the after
noon tile 11 o'clock at night.—

Probatum est.—

Colonel Blackburn's Specific against Muskitoe bites
in the Month of July.

Rippon Lodge.——— July 1797.

MOSQUITOES. This drawing by B.H. Latrobe of "Colonel Blackburn's specific against muskitoe bites" may seem to us a humorous drawing, but to the squire of Rippon Lodge on Neabsco Creek with its many marshes, mosquitoes were deadly serious. As recently as 1900, there were over 500,000 deaths in the United States from malaria annually. In late summer of 1999, there were two confirmed cases of malaria on Long Island, New York. (MHS — II-19.)

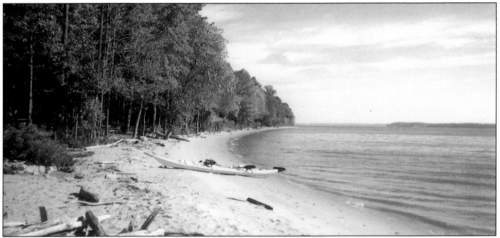

LEESYLVANIA, VIRGINIA. Since 1975, Leesylvania has been a Virginia State Park of 505 acres with scenic beaches on the Potomac, as shown above. It was the site of an 18th-century Lee family home, the ruins of which were photographed in 1936 for the Historic American Building Survey. (AKCo.)

COCKPIT POINT AND POSSUM NOSE. Cockpit Point was almost ideal for a Confederate installation of batteries to attack Union shipping on the Potomac. The low plateau of the point itself was suitable for a water battery, while the wooded hills behind, Possum Nose, lent themselves to concealed batteries that could fire down on shipping. (FtWd.)

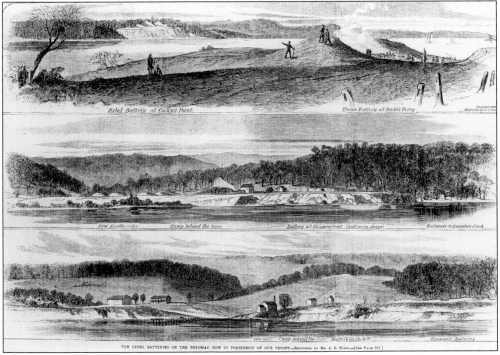

QUANTICO CREEK. The mouth of Quantico Creek was one of the most heavily armed points on the Virginia shore during 1861. With Cockpit Point battery upriver, Shipping Point at the mouth of the creek, and Evansport on the down river side, this complex effectively sealed the Potomac against any ships (other than gunboats) trying to supply Washington. This blockade lasted until March 9, 1862. This engraving from *Harper's Weekly* depicts the captured batteries. (FtWd.)

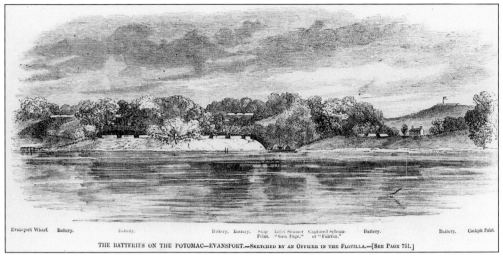

Evansport Wharf. Battery. Battery. Battery. Battery. Ship Rebel Steamer Captured Schoon- Battery. Battery. Cockpit Point.

Point. "Geo. Page." er "Fairfax."

THE BATTERIES ON THE POTOMAC—EVANSPORT.—SKETCHED BY AN OFFICER IN THE FLOTILLA.—[SEE PAGE 751.]

EVANSPORT, VIRGINIA. Evansport is a town that has disappeared into Quantico Marine Corps Base. However, during the Civil War, it was most prominent as a strong Confederate position in the 1861 blockade of Washington. Located at the mouth of Quantico Creek, the engraving above from *Harper's Weekly* shows three Confederate positions: Evansport to the left, Shipping Point in the middle, and Cockpit Point to the right. The hill behind Cockpit Point is Possum Nose. On October 15, 1861, the Evansport batteries were engaged by the U.S.S. *Seminole* and the U.S.S. *Pocahontas*. *Harper's Weekly* got it backwards: the ships were going downstream, not upstream as this November 2, 1861 engraving shows. (FtWd.)

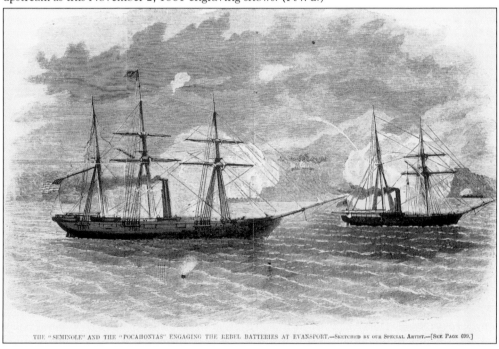

THE "SEMINOLE" AND THE "POCAHONTAS" ENGAGING THE REBEL BATTERIES AT EVANSPORT.—SKETCHED BY OUR SPECIAL ARTIST.—[SEE PAGE 699.]

116

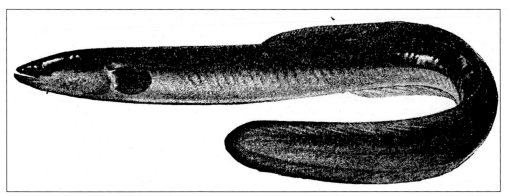

AMERICAN EEL. This is the only catadromous fish (meaning that it spends most of its life in fresh water but spawns in the sea) found in the Potomac. The American Eel breeds in the Sargasso Sea and the young eels must make a journey of about 1,500 miles back to the Potomac to mature. Eels have become an important commercial fish locally and are flown live to the European markets. (J.)

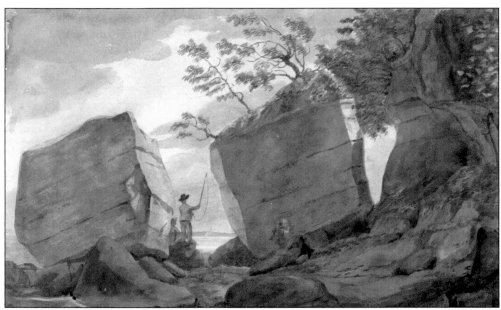

FREESTONE. Freestone is stone that may be cut freely without cracking. Sandstone blocks such as these were used in building the public buildings of Washington. The above painting was made by H.B. Latrobe on August 21, 1806, at Clifton Point in Stafford County, Virginia, (MHS — IX-10.)

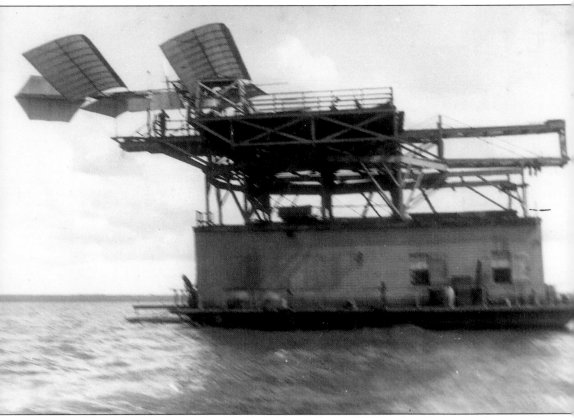

THE AERODROME. On October 7, 1903, over two months before the Wright brothers would successfully fly a heavier-than-air craft at Kitty Hawk, North Carolina, Prof. Samuel P. Langley, Secretary of the Smithsonian Institution, attempted to fly his *Aerodrome* from a barge anchored in the Potomac at Widewater off Brent Point, Virginia. The army had supported Langley's research into steam-powered flying machines since 1898, at a cost of $50,000. Langley built a model that flew successfully, but as soon as the *Aerodrome* left the barge it disintegrated, nearly killing the pilot, Charles M. Manly. Ironically, the fault was in the landing gear, not in the air ship. (MLK – 426.)

Tulip Poplar. This beautiful, tall tree, sometimes called Yellow-Poplar or White Wood, is found through out the basin. The common height is 50 to 70 feet, but old trees may reach 190 feet with a trunk eight feet in diameter. There are many plants that have the strange distribution of Eastern North America and Eastern Asia; the Tulip Tree is one of these. In Japan, this tree is called the Kimono Tree because of the resemblance of the leaf shape to a Kimono pattern. (Trees.)

Aquia Quarries. From 1791 until the supply was exhausted about 1817, the building stone for the public buildings in Washington came from the Aquia Creek quarries. After President Jefferson appointed Benjamin Henry Latrobe surveyor of public buildings in 1803, Latrobe visited the quarries in August of 1806 and made this drawing. (MHS — IX-8.)

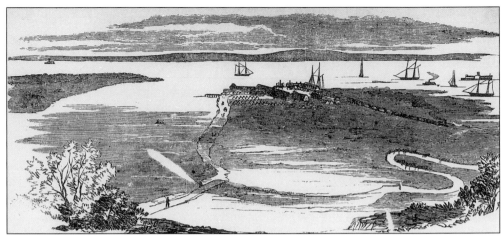

AQUIA CREEK. The Confederacy located its first Potomac battery at Aquia Creek. The area referred to as Aquia Creek is a complex consisting of Brent Point to the north of Aquia Creek, Marlborough Point between Aquia and Potomac Creeks, and Belle Plain south of Potomac Creek. Because of the presence of existing railroad wharves, the main Confederate concentration was on Marlborough Point, as shown in the December 6, 1862, *Harper's Weekly* engraving above. In addition to land batteries, Aquia Creek was also defended by a steam ship, the C.S.S. *City of Richmond* (formerly the *George Page*, an Alexandria/ Washington ferry). Shown below in an engraving from *Harper's Weekly*, October 5, 1861. The Confederates burned the *Page* when they abandoned Aquia Creek on March 9, 1862. (MLK — 5892 & FtWd.)

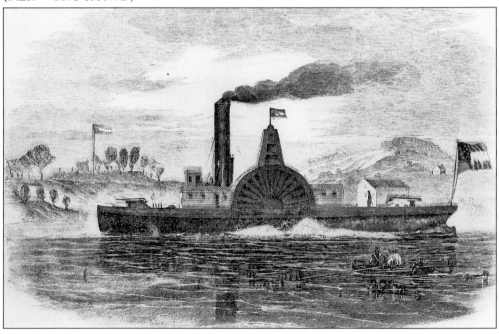

THE MOUTH OF AQUIA CREEK. After the Civil War, a clerk in the Paymaster General's Office in Washington traveled the Potomac making sketches. William G. Newton was an amateur artist who captured this hotbed of war after it returned to a tranquil peace. (HSW — Newton 171.)

BELLE PLAIN, STAFFORD COUNTY, VIRGINIA. As soon as the Rebel forces were cleared from the Aquia Creek area, about March 9, 1862, the wharves were restored and buildings were built. Belle Plain, just south of Potomac Creek, became one of the principal supply centers for the Union's Army of the Potomac. The confusion is depicted in this 1862 engraving from *Harper's Weekly.* (FtWd.)

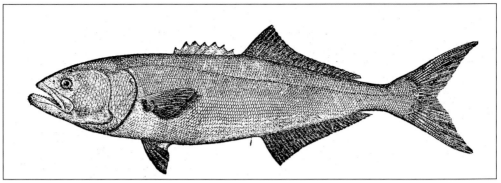

BLUEFISH. An important marine food and sport fish, the Bluefish has been described by most authors as a sloppy killer of other fish. Terms have been used to describe it like an "animated chopping-machine" or a "pack of hungry wolves." These fish move through a school of fish, snapping at the prey fish and leaving a trail of fragments and blood in the water. (J.)

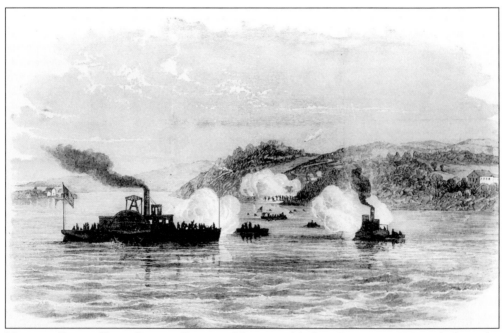

MATHIAS POINT, KING GEORGE COUNTY, VIRGINIA. Mathias Point is 4,000 yards from the Maryland shore; it is about 20 feet above the water and commands the narrow channel against the Virginia shore. This was considered an ideal situation for a Confederate battery to control Union shipping on the Potomac. On June 17, 1861, a Union Naval party, under the authority of Commander James Harmon Ward, attempted to establish a Union battery here. In the ensuing fight, Commander Ward was killed, the first U.S. Naval officer to die in the Civil War. This 1898 engraving from *Official and Illustrated War Record* is inaccurate in that the *Reliance* was not present and the ship's guns were not firing. (FtWd.)

122

SWAMP WHITE OAK. Not only are many oak species very similar, but they also hybridize, producing intermediate forms. This large tree is relatively common near the edges of swamps or ponds. The leaves are large, six to eight inches long, and deep green in color. Maybe the easiest way to identify this species is by the extremely long (one to four inches) stalk of its acorns. (L.)

GUMBO CREEK, KING GEORGES COUNTY, VIRGINIA. Gumbo Creek was originally Gamble Creek; at some point it was apparently misspelled as Gumbo Creek. On April 22, 1865, the presidential assassin, John Wilkes Booth, and his accomplice, David E. Herold, landed here, having rowed across the Potomac from Charles County Maryland. On the morning of April 26th, a Union search party caught up with Booth and, while Herold surrendered, Booth was shot and killed. (FG.)

SOURWOOD. This small tree is frequently missed until fall, when its leaves take on some of the most brilliant colors in the forest, from scarlet to dark wine. The thin, pendulous flower clusters appear in mid-summer. (L.)

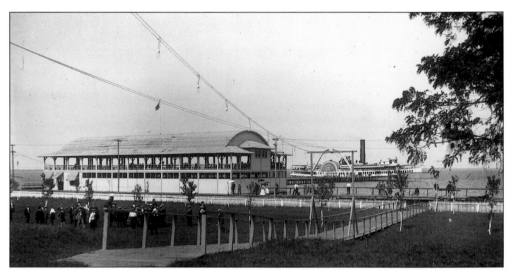

COLONIAL BEACH, VIRGINIA. This resort community was incorporated in 1892. Many Washingtonians had summer homes in Colonial Beach, including Alexander Graham Bell. The river steamers stopped here and a great attraction, besides gambling, was dancing in the pavilions over the river. At the turn of the century, the town was thriving as a tourist destination. Today, it is once again a desirable location for summer and vacation homes. (HSW — CHS-10103.)

ROCKFISH OR STRIPED BASS. In 1984, the local jurisdictions recognized that the Rockfish population had crashed and that we were in danger of loosing this important commercial and sport fishing resource. A five-year moratorium was imposed on the taking of this species. The program was successful, and now with the population back, Stripers represent an area of conflict between commercial fisherman and sport anglers. The catch has steadily increased and the sportsmen are convinced that commercial fishermen are depriving them of trophy fish. (J.)

WAKEFIELD, POPES CREEK, VIRGINIA. This reconstruction of the house where George Washington was born was built by the Wakefield National Memorial Association in 1931. The area is now the George Washington Birthplace National Monument and administered by the National Park Service. The Visitor's Center is located on the banks of Popes Creek, with a nice beach at its base, suitable for canoe or kayak pull outs. Wakefield is located in Westmoreland County, founded in 1653, together with Northumberland County (1645) to the east; it is one of the oldest counties on the Northern Neck. (NPS.)

125

MENHADEN. These marine fish are high in oil and are fished commercially for fertilizer. Kinsale is a major port for the processing of Menhaden. (J.)

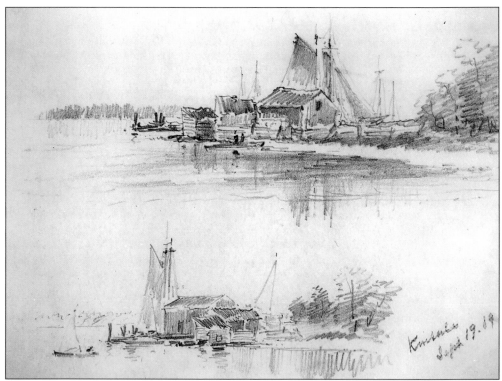

KINSALE, VIRGINIA. William G. Newton, the Washington clerk, made these sketches of the busy fishing port of Kinsale on September 19, 1889. This shipping point and trade center on the Yeocomico River was officially founded in 1705. Kinsale was the site of a heroic battle in the War of 1812. Five British barges entered the cove in front of the town. The American vessel *Asp*, under command of Midshipman James B. Sigourney of Boston, managed to fight off four of the British flotilla, but the fifth came alongside the *Asp* and boarded her. Finding Sigourney mortally wounded and tied to the mast, still directing the fighting, an Englishman leveled his gun and shot the midshipman. Sigourney is buried at Kinsale. (HSW — Newton 74.)

126

SUNNYBANK FERRY. One of the last ferries on Potomac tributaries, is the Sunnybank Ferry across the Little Wicomico River in Northumberland County, Virginia. (AKCo.)

SMITH POINT, VIRGINIA. After our rigorous trip down the Potomac River, it is appropriate that we take our shoes off and relax in the sand of Smith Point with the Chesapeake Bay lapping at our feet. (AKCo.)

Picture Credits

Atlantic Kayak, 1201 North Royal Street, Alexandria, Virginia 22314. pp. 90, 94, 95, 108, 113, 114, 127. (AKCo.)

Charles County Tourism, P.O. Box B, LaPlata, Maryland 20646. p. 98. (CC.)

Michael D. Clover. p. 53. (MC.)

District of Columbia Public Library, Martin Luther King Jr., Washingtonian Division. pp. 4, 10, 13, 27, 29, 30, 33, 41, 49, 53, 54, 55, 57, 58, 60, 62, 63, 64, 65, 66, 67, 68, 69, 71, 73, 74, 75, 76, 77, 78, 79, 80, 85, 87, 93, 96, 97, 112, 118, 120 (MLK.)

Fort Ward Museum Library (Copy Prints Pam Minor, Photo Solutions). pp. 22-23, 29, 30, 32, 35, 36, 39, 40, 45, 46, 48, 72, 84, 89, 92, 98, 99, 101, 115, 116, 120, 121, 122. (FtWd.)

George Washington Masonic National Memorial. p. 88. (GWM.)

Franz Gimmler, Potomac Water Trail Association pp. 72, 102, 103, 123. (FG.)

Donald A. Hawkins. pp. 2, 9, 25, 43, 61, 81, 91, 109. (DH.)

Historic American Building Survey. pp. 51, 92, 96. (HABS.)

The Historical Society of Washington, D.C. pp. 6, 65, 75, 82-83, 88, 90, 104, 111, 121, 124, 126. (HSW.)

Kiplinger Washington Collection. pp. 44, 52, 56, 64, 66. (Kip.)

Andrei Kushnir, Taylor & Sons Fine Art, 666 Pennsylvania Avenue, SE, Washington, DC 20003. p. 51. (AK.)

Maryland Department of Natural Resources. pp. 56, 58, 89, 104, 105, 110. (DNR.)

Maryland Historical Society. pp. 16, 20, 21, 27, 33, 36, 37, 38, 41, 45, 46, 47, 52, 59, 62, 93, 94, 100, 105, 111, 114, 117, 119. (MHS.)

Maryland State Archives. pp. 15, 20, 21, 103. (MSA.)

National Archives and Records Administration, Special Media Archives Services Division. pp. 106-107. (NARA.)

National Park Service. p. 125. (NPS.)

Naval Historical Foundation. p. 99. (NH.)

Robert P. Pauline, Potomac Water Trail Association p. 101. (RP.)

Michael Piecnocinski, Veerhoff Galleries, 1054 31st Street NW, Washington, DC 20007. pp. 47, 50. (MP.)

Donald Schomette. p. 100. (DS.)

Steve Swartz, Potomac Water Trail Association. p. 67. (SS.)

Neal Welch, Maryland Department of Natural Resources. pp. 17, 18, 19. (NW.)

Westvaco, Fine Paper Division, 300 Pratt Street, Luke, Maryland 21540-1099. p. 13. (WCo.)

Frank Wright, Art Department, George Washington University, Washington, DC 20052. p. 70. (FW.)

American Turf Register. November 1833. p. 19. (ATR.)

Browning, Meshach. *Forty-Four Years of the Life of a Hunter*. Philadelphia: J.B. Lippincott Company, 1859. p. 12. (Br.)

Coues, Elliott. *Key to North American Birds*. New York: Dodd and Mead, 1872. pp. 113. (C.)

Dana, Mrs. William Starr. *How to Know the Wild Flowers*. New York: Charles Scribner's Sons, 1893. pp. 11, 34, 110. (D.)

Jordan, David Starr. *A Guide to the Study of Fishes*. New York: Henry Holt and Company, 1905. pp. 24, 49, 59, 117, 122, 125, 126. (J.)

Jordan, David S., Vernon L. Kellogg, and Harold Heath. *Animals*. New York: D. Appleton and Company, 1902. pp. 35, 48. (JKH.)

Knowlton, Frank H. *Birds of the World*. New York: Henry Holt and Company, 1909. pp. 24, 34, 86. (K.)

Lounsberry, Alice. *Guide to the Trees*. New York: Frederick A. Stokes Company, 1900. pp. 15, 31, 34, 57, 84, 112, 123, 124. (L.)

Merriam, Florence A. *Birds of Village and Field*. Boston: Houghton, Mifflin and Company, 1898. pp. 18, 42. (M.)

Rennie, James. *Natural History of Birds*. New York: Harper & Brothers, 1840. p. 95. (R.)

USDA. *Trees*. Washington: GPO, 1949. pp. 10, 14, 28, 108, 119. (Trees.)

Winslow, Benjamin. "A Plan of the Upper Part of the Potomack River," 1736. p. 26. (Wi.)

Wild Flowers of America. New York: G.H. Buek & Co., 1894. pp. 11, 14, 28, 42. (B.)

Wright, Mabel Osgood. *Flowers and Ferns in Their Haunts*. New York: The MacMillan Company, 1901. pp. 19, 31. (W.)